IMAGES
of America

PACIFIC PALISADES

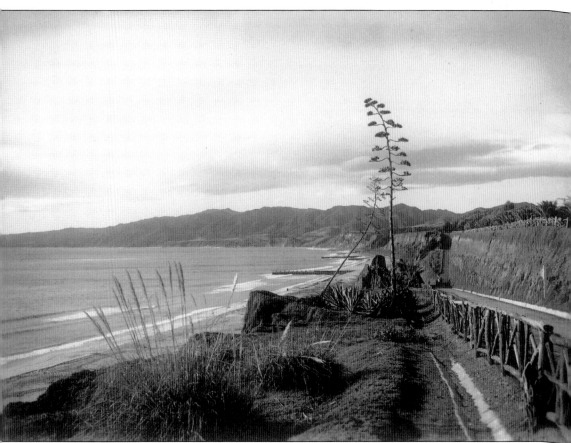

PACIFIC PALISADES. This view of the impressive bluffs that front the Pacific Palisades was taken from the Santa Monica Incline around 1925. The fence on the bluff to the right forms the edge of Palisades Park in Santa Monica. It is easy to see why the looming rock formations reminded the early promoters of similar formations along the Hudson River. (Courtesy of the Santa Monica Land and Water Company Archives.)

ON THE COVER: Pictured here in front of the Business Block, the group of people working to develop Pacific Palisades, the Pacific Palisades Association, poses for the camera in 1928. The association was incorporated in 1921 under the supervision of the Southern California Annual Conference of the Methodist Episcopal Church to create a Chautauqua campsite and a religious community in the area now known as the Pacific Palisades. (Courtesy of the Santa Monica Land and Water Company Archives.)

IMAGES
of America

PACIFIC PALISADES

Jan Loomis

ARCADIA
PUBLISHING

Published by Arcadia Publishing
Charleston, South Carolina

Printed in the United States of America

Library of Congress Control Number: 2008941500

For all general information contact Arcadia Publishing at:
Telephone 843-853-2070
Fax 843-853-0044
E-mail sales@arcadiapublishing.com
For customer service and orders:
Toll-Free 1-888-313-2665

Visit us on the Internet at www.arcadiapublishing.com

*For Justin, Julia, Joann, Garrett, and Matthew, who will live the future,
so they will know where their family lived and worked in the past.*

CONTENTS

ACKNOWLEDGMENTS

Many of the deeds for West Los Angeles property include a reference to the Santa Monica Land and Water Company. During its almost 100 years of operation, this early California corporation was involved in the development of Santa Monica, Brentwood, Pacific Palisades, and Bel Air. Many people worked directly for the company or were involved with it during the years that it sold lots and homes in the West Los Angeles area. The Santa Monica Land and Water Company generated files, ledgers, photographs, and other ephemera during its years in business.

Thanks to Lois Flagg, the longtime secretary of the company, for this treasure trove of historical documents and photographs that was preserved and remains to tell the tale of how these communities developed.

In addition to having access to these business records, I was also privileged to know a number of Palisadians. Dorothy Gillis Loomis, Arthur Laurence Loomis, Adelaide Gillis McCormick, Frances McCormick Armstrong, Margaret Inez Loomis, Phyllis Genovese, Denis Lee, Zola Clearwater, Ada Werk, and many other residents shared memories and stories with me that are recorded in this book.

Images of America: *Pacific Palisades* is a companion to the Images of America: *Brentwood* book, published in 2008, and it completes the story of how the Rancho San Vicente y Santa Monica and the Rancho Boca de Santa Monica changed from farming and grazing land into the thriving communities of today.

The photographs and ephemera published in this book are from the Santa Monica Land and Water Company Archives unless otherwise noted. Many have never been published before.

My thanks also to the archivists at the University of Southern California Libraries, the Santa Monica Public Library, the Los Angeles Public Library, and the Charles E. Young Research Library, UCLA, for their assistance. My gratitude goes to Betty Lou Young, Randy Young, and the Pacific Palisades Historical Society for their numerous publications and preservation efforts. Many thanks also to my husband, Robert L. Loomis, for his meticulous research, his scanning skills, and his memories of his childhood in Pacific Palisades. Without his unfailing support of this project, it could not have happened.

INTRODUCTION

The California coast west of Los Angeles winds its way north at the base of massive rock formations that slope down to the sea and sand beaches. On the top of the bluffs, green mesas stretch to the mountains cut by canyons filled with streams and trees. There is plenty of evidence that the earliest settlers of the area were migrant Native American tribes travelling between the San Fernando Valley and the beach. The abundant water, plants, wildlife, and seafood would have provided the tribes with the subsistence they needed. The grinding stones and pottery shards that turn up occasionally remain as mute testimony to a simple lifestyle lived out on the mesas.

European sailors found the area in 1592, sailing up the coast while exploring for Spain. Later ships occasionally anchored in the bay to resupply with water and food. The first Spanish land-based expedition camped near the Gabrielino Tongva village at the twin springs located on the University High School grounds in West Los Angeles. The story goes that the sailors named the springs for the mother of St. Augustine because the clear water reminded them of the endless tears she shed over her son's dissipated lifestyle.

In 1839, Don Francisco Sepulveda was granted a title to land he had been ranching since around 1828. He called his property the Rancho San Vicente y Santa Monica. That same year, the Rancho Boca de Santa Monica was granted to Francisco Marquez and Ysidro Reyes. Today the communities of Santa Monica, Brentwood, and Pacific Palisades thrive within the boundaries of those original ranchos.

By the 1870s, the ranchos had passed from their original owners to the Americans who had flooded into California after the 1849 Gold Rush. Col. Robert Symington Baker bought the Rancho San Vicente y Santa Monica from the Sepulveda heirs, and the Boca de Santa Monica had been sold to various "gringos."

Baker sold two-thirds of his holdings to Nevada senator John Percival Jones. Jones saw the bay as the solution that could break the hold of the Southern Pacific Railroad on shipping in California. He wanted to create a rail line and a wharf that would let him ship silver ore from his Panamint mines in Northern California to ships waiting in Santa Monica Bay. With Baker and a group of Los Angeles businessmen, Jones began developing the "Long Wharf" and the Los Angeles and Independence Railroad. Jones and Baker also laid out a new town near their burgeoning harbor operation. The first lots in Santa Monica were sold in 1875, and soon the town was flourishing.

The same could not be said for the Long Wharf and the Los Angeles and Independence Railroad. With the economic downturn of 1877, work stopped on the rail line, and it was eventually sold to the Southern Pacific. San Pedro became the port for Los Angeles and the Long Wharf dwindled into obscurity.

Baker sold his remaining land to his wife, Arcadia Bandini de Baker, and in 1897 she and Senator Jones formed the Santa Monica Land and Water Company. Their land holdings were placed in the corporation, and its stock was sold to Robert Conran Gillis in 1904. Gillis saw his land purchase as an opportunity to develop residential neighborhoods, and during the next 40 years he was involved in the creation of Westgate, Westgate Gardens, Westgate Heights, and Brentwood Park. He developed the Palisades Tract in Santa Monica and participated in the founding of the Pacific Palisades. Other developments he was instrumental in creating include the Huntington Palisades, the Riviera, Canyon Mesa, Canyon Vista, and Bel Air.

In the meantime, the Boca de Santa Monica was split among Marquez family members into various parcels and sold. Gillis bought land in Santa Monica Canyon to add to his holdings. Abbott Kinney (the founder of Venice) bought the land on the mesa west of Santa Monica Canyon (now the Huntington Palisades). Kinney planted eucalyptus trees on the land, some of which still remain, and planned a pleasant suburb called Santa Monica Heights. (The trees are

visible in the photograph at the end of this section.) Other groups bought chunks of the mesa. The Marquez family retained some parcels in Santa Monica Canyon.

As part of the plan for their new town, Baker and Jones left the mesa land closest to the bluff as open space. Eventually the land was deeded to the city and became known as Palisades Park.

In 1905, Gillis began the development of the Westgate subdivision outside the West Gate of the Old Soldier's Home in what is now Brentwood. At about the same time, he began development of land on the edge of Santa Monica Canyon, calling this subdivision "the Palisades." Conceived as beach homes for Los Angeles residents, the Palisades quickly became home to many prominent Angelinos.

By the early 1920s, Santa Monica and Brentwood were thriving communities, and attention began to turn to the canyons and mesas west of Santa Monica for development. At about the same time, the Southern California Conference of the Methodist Episcopal Church tasked Dr. Charles Holmes Scott to find a new home for their thriving Chautauqua operation, which was rapidly outgrowing its Huntington Beach location. The Boca de Santa Monica seemed to be a perfect site—open rolling mesas, stunning ocean views, and located near a thriving community but not yet encroached on by the city. Playing on the already established Palisades name, Scott formed the Pacific Palisades Association and founded a community built around the principles of the Chautauqua movement called Pacific Palisades.

The new community thrived under the association's leadership as visitors to Chautauqua educational programs leased lots and became residents. A small business center was built, and the new community soon had a grocery store and a hardware store in addition to the meeting hall and campsite. (The streets of the new community are also visible in the photograph at the end of this section.) The mesa once owned by Abbott Kinney was purchased from its current owner, the Huntington estate, and an upscale housing development was planned. The Great Depression derailed the association's plans, causing it to abandon the physical development of the community to concentrate on the educational and moral aspects of the movement. R. C. Gillis made an agreement with the association to continue the residential developments. He formed the Pacific Land Corporation to complete the task, and his Santa Monica Land and Water Company became the exclusive sales agent for Huntington Palisades. The area's natural assets, combined with a major expenditure of funds and effort on infrastructure, caused the community to ultimately thrive. Today it is a prosperous upscale neighborhood that cherishes it roots and its village environment as well as its urban location.

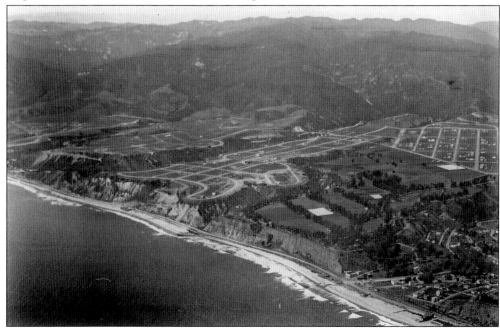

One

THE LAND

RAMPARTS, CANYONS, AND MESAS

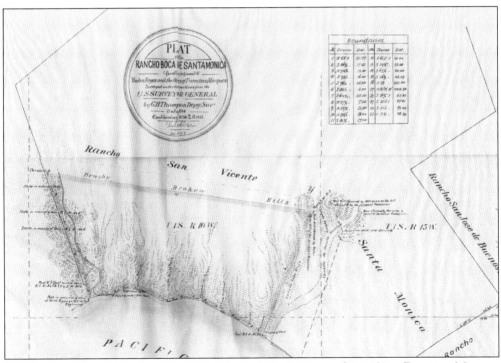

THE RANCHO BOCA. The Rancho Boca de Santa Monica, granted in 1839 to Francisco Marquez and Ysidro Reyes, was bounded by the Pacific Ocean to the south and by the Rancho San Vicente y Santa Monica, owned by the Sepulveda family, to the north and east. Both owners claimed the Santa Monica Canyon area, leading to a boundary dispute. The argument ran on for many years and was finally settled by the courts in 1882.

THE RANCHO. Ysidro Reyes (pictured) and Francisco Marquez were granted the Boca de Santa Monica in 1839. Born in Los Angeles, Reyes was part of the family who owned the Rancho Las Virgines in present-day Agoura. Reyes built an adobe near where Sunset Boulevard intersects Chautauqua Boulevard. Eventually the two families intermarried, and the Marquez name is a familiar one still in Pacific Palisades. (Courtesy of the University of Southern California, on behalf of the USC Special Collections.)

FRANCISCO SEPULVEDA. Arriving in California in 1781 as a six-year-old child with the Fernando Rivera y Moncada expedition, Sepulveda served as a soldier at the San Diego presidio. He settled in Los Angeles in 1815 and was acting alcalde (mayor) of the city in 1825. By 1828, he held grazing rights on land that stretched from Rancho Ballona (Marina del Rey) to the Santa Monica Mountains. (Courtesy of the University of Southern California, on behalf of the USC Special Collections.)

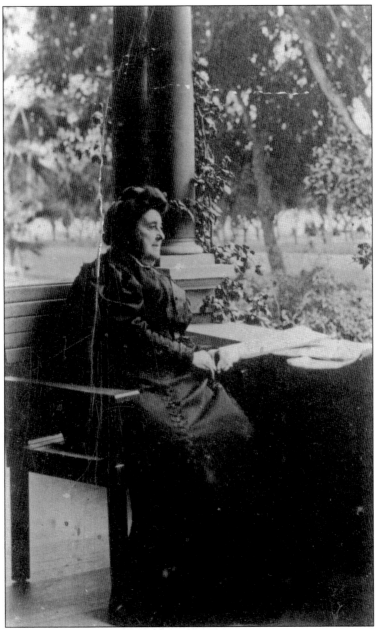

ARCADIA BANDINI DE BAKER. R. S. Baker deeded his Rancho San Vicente y Santa Monica land to his wife, Arcadia, in 1887. She and Nevada senator John Percival Jones formed the Santa Monica Land and Water Company in 1897 to hold their adjoining lands. For many years she maintained a home on Ocean Avenue overlooking Palisades Park and the coast, where this picture was taken. She had no children, but her home was always full of nieces and nephews. She and Senator Jones donated the land for the Soldier's Home (Veterans Administration) in Brentwood. Often called the "Godmother of Santa Monica," she and Senator Jones donated many parcels of land to Santa Monica in addition to Palisades Park, including Lincoln Park and the right-of-way for the trolley line on San Vicente Boulevard. She died in 1912 at age 85, leaving her family one of the largest fortunes amassed in California at that time.

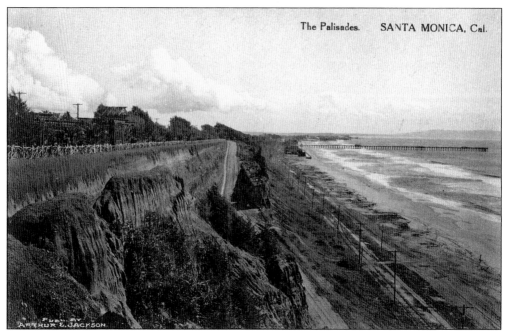

The Palisades. SANTA MONICA, Cal.

THE PALISADES. The edge of the bluff in the new town of Santa Monica was preserved as open space when Sen. John Jones and R. S. Baker laid out the town of Santa Monica. In this early postcard, the bluffs and the early dirt road that led down to the beach are visible. The Santa Monica Pier is in the distance. The tracks led to the Long Wharf.

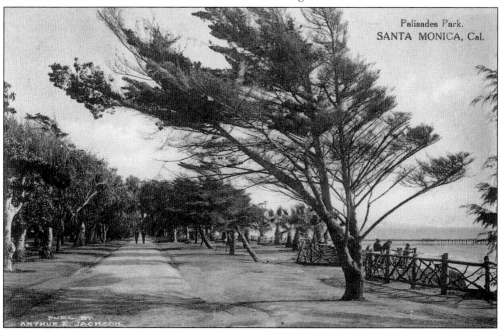

Palisades Park. SANTA MONICA, Cal.

PALISADES PARK. The land for the park, located between the pier and what is now Montana Avenue, was officially donated to the new city in 1892 by Arcadia Bandini de Baker on the condition that it be maintained as open space forever. The portion between Adelaide Drive and Ocean Avenue was donated by the Santa Monica Land and Water Company in 1911 to complete the park.

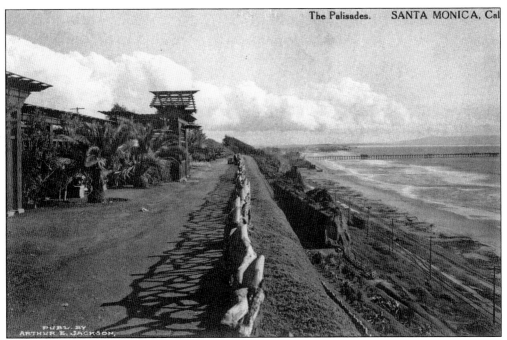

The Palisades. SANTA MONICA, Cal

WISH YOU WERE HERE. The redwood pergola pictured in this postcard is still a part of Palisades Park, offering shade and spectacular views of Santa Monica Bay and the coastline all the way to Palos Verdes. This postcard was undoubtedly sent to friends or relatives back east to show them the glories of Santa Monica and the Pacific Ocean.

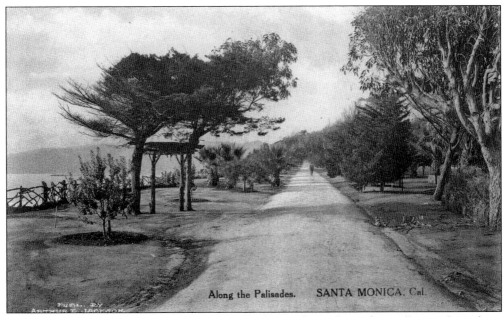

Along the Palisades. SANTA MONICA, Cal.

STROLLS AND PICNICS. Palisades Park has always been a favored spot for strolling and watching the sunset. This early postcard shows the park before the palm trees replaced the evergreens. The bluffs of Pacific Palisades and the Long Wharf are visible in the background.

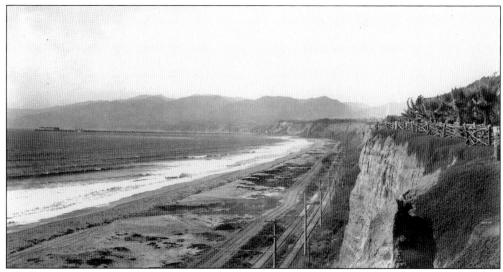

THE MOUNTAINS AND THE SEA. Looking north toward Pacific Palisades, it is easy to see how these bluffs compare to those along the Hudson River. It is also easy to see why the Pacific Palisades is often described as where "the mountains meet the sea." The Long Wharf, located at the foot of Potrero Canyon, is visible along with the railroad tracks that paralleled the Palisades.

THE BOCA. The mouth (*boca* in Spanish) of Santa Monica Canyon was the subject of a long running dispute over ownership between the owners of the Rancho San Vicente y Santa Monica and the owners of the Rancho Boca de Santa Monica. This photograph of the canyon was taken from Adelaide Drive, the edge of the Palisades Tract developed in the early 1900s as an upscale beach community for Los Angeles residents.

WAVING FIELDS OF GRASS. Santa Monica Canyon was covered with grass as far as the eye can see before it was subdivided into streets of homes. Agriculture was an important revenue stream for the area in the early 1900s. The lima bean crop harvested in the area was worth more than $400,000 in 1904.

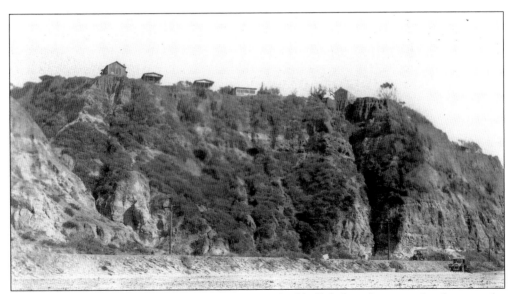

PACIFIC PALISADES. This up-close photograph of the bluffs below the mesa that became the Huntington Palisades reveals the imposing height and ruggedness of the cliffs. It also shows the cabins of those who built ad hoc dwellings as vacation homes before the area was developed. Note the two cars on what was to become the Coast Highway.

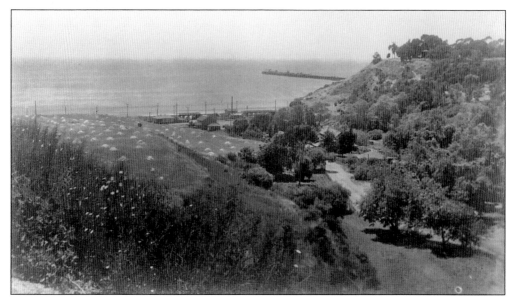

THE LONG WHARF. This photograph shows the view down Santa Monica Canyon to the ocean and the Long Wharf. The buildings are the early bathhouses and stores that served the tourists who came from Santa Monica and Los Angeles to enjoy the beach. The mesa on the right became the Huntington Palisades. Some of the trees on the mesa are the eucalyptus planted by Abbott Kinney when he owned the mesa.

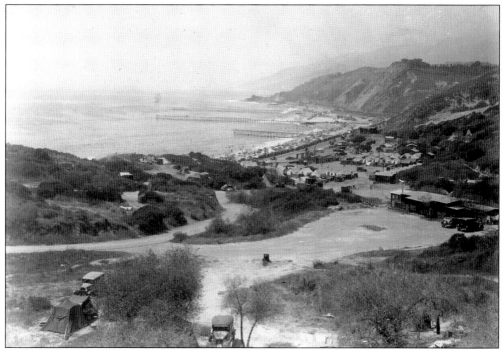

JONES BOWL. Angelinos drove to the area north of Santa Monica to camp and enjoy the beach. They parked their automobiles and pitched their tents at the Palisades Auto Camp. The bowl was located at the foot of Temescal Canyon. This c. 1930 photograph shows how popular the beach had become.

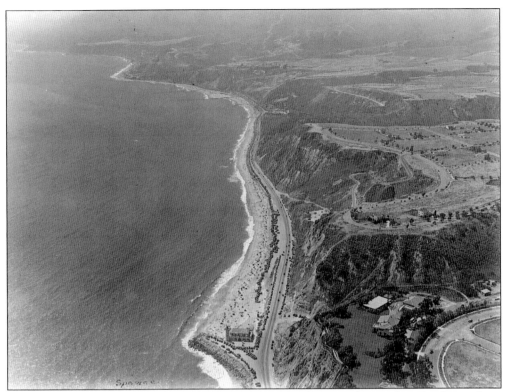

PACIFIC PALISADES. This aerial shot shows the mesas that became the Pacific Palisades in about 1926. The Long Wharf is gone, torn down in 1923. The popularity of the beach continues with cars parked side by side along the highway. Houses are gradually springing up in the Huntington Palisades and the other areas owned by the Pacific Palisades Association.

TEMESCAL CANYON. Graced with trees and streams, the Temescal Canyon became the home of the Pacific Palisades Association's Chautauqua program. Performances and educational lectures of all types were held in the amphitheater the association built. Attendees camped in semipermanent tents and ate meals in the dining hall.

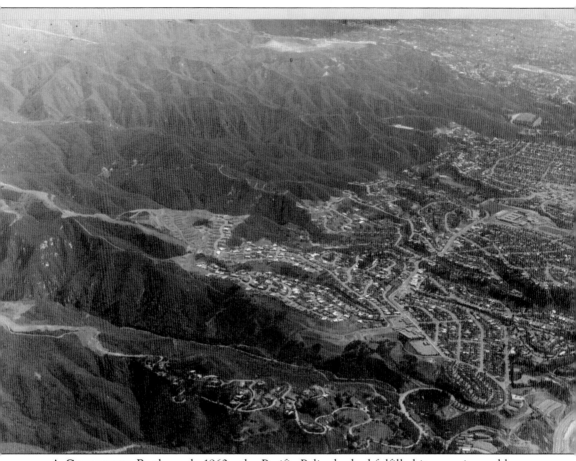

A COMMUNITY. By the early 1960s, the Pacific Palisades had fulfilled its promise and become home to a growing population of urbanites who enjoyed its proximity to the beach, its sense of community, and its smog-free air. Housing tracts have pushed up into the canyons, and the new Pacific Palisades High School is complete in Temescal Canyon. The subdivision in the foreground is Castellammare. Santa Inez Canyon, the future site of the Palisades Highlands, is not yet developed. The Marquez Knolls and Lachman subdivisions are the next housing areas. The original areas developed are beyond the high school, and Santa Monica is in the distance.

Two

THE PROMOTERS
SUBDIVIDING FOR COMMUNITIES

LOTS ON TOP. R. S. Baker and Sen. John Percival Jones started selling lots on top of the palisades fronting the coastline of their Rancho San Vicente y Santa Monica in 1875. The climate, the beach, and the prices ($350 per lot) quickly attracted residents. By the early 1900s, the area had also caught the attention of prominent Los Angeles businessmen, both as an investment and as a place to live.

PALISADES TRACT. Robert C. Gillis and his wife, Frances, relax on the porch of their Adelaide Drive home located on the edge of the Santa Monica Canyon in the Palisades Tract. Gillis developed the tract with large lots and wide streets. The alleys behind the homes opened originally into stables that quickly gave way to garages for automobiles. The family used the house as a summer home for many years.

ABBOTT KINNEY. While Kinney is best known for his development of Venice, one of his first projects was on the bluffs north of Santa Monica overlooking the Long Wharf. He purchased the land from the Marquez family and laid out a subdivision he called Santa Monica Heights. Kinney planted a number of eucalyptus trees and laid out a neat street grid that can be seen in early aerial photographs. Some of the trees survived, but the subdivision was never built. (Courtesy of Security Pacific Collection/ Los Angeles Public Library.)

MYRON HUNT. The Palisades Tract was designed with large lots, and the advantages of the ocean views and beach access were obvious. The development was intended to rival Pasadena and other upscale California neighborhoods in its ambiance. Many of these early homes were designed in the California craftsman style by prominent architects such as Myron Hunt and Elmer Grey. Hunt went on to design the Rose Bowl and many other Los Angeles landmarks. (Courtesy of Security Pacific Collection/ Los Angeles Public Library.)

SUNDAY, DECEMBER 17, 1905. 6

PALISADES

"The Burlingame of Southern California"

THE Palisades possesses the grandest "bouquet of scenic charms" in Southern California. With the verdant and picturesque Santa Monica Canyon on the one side, the pretty town of Santa Monica on the other, the rolling foothills and mountain peaks in the rear, and the everchanging grandeur of the mighty ocean in front—The Palisades is truly a beautiful "setting in a ring of scenic delights." No residence subdivision on the Southern Coast includes such a myriad of natural attractions. No property hereabouts has such intrinsic merit.

Dominant Features of the Scenic Palisades

1. The property is located on a majestic bluff, towering high above the water line. The sweeping coast line view from the edge of the bluff is a source of inspiration to the observer.

2. The lots are 160x175 with private alleys. No subdivision in the west has a higher type of improvements. The system of boulevards, sidewalks, curbs, water facilities, gas, sewers, electricity, etc., has been laid out by master hands.

3. Shade trees, ornamental shrubbery and a beautiful private park system will also be included among the improvements.

4. Protective building restrictions will preserve a harmony of environment. When all improvements are completed the Palisades will rival the famous Burlingame near San Francisco, and Manchester-by-the-Sea—the great Atlantic resort near Boston.

5. The Palisades is within easy distance of Los Angeles and all the beaches. Frequent and speedy car service renders the Palisades the ideal place of residence for the man whose business interests are in Los Angeles.

6. Beautiful Ocean Avenue—"the pride of Santa Monica"—extends in front of the Palisades property.

7. The magnificent San Vincente Road—the grandest scenic thoroughfare in the State—extends from the Palisades to the Soldiers' Home, and passes Westgate, Westgate Acres and Brentwood Park.

8. The Palisades stands out in striking contrast to the ordinary, desolate "sand lot" propositions. A glance at the property is sufficient. No further argument is necessary.

A Private Beach 800 Feet Long at the Foot of the Bluff

This beautiful beach is for the exclusive use of Palisades residents. Two handsome driveways extend from Ocean Avenue to this beach.

An investigation will prove to your satisfaction that The Palisades is the "superlative idea" in ocean side residence property. A comparatively few lots remain unsold. They are purchasable today at consistent prices. Aside from a purely residence standpoint, they are unrivaled as speculative subjects. Take any Santa Monica car at Fourth and Hill streets for The Palisades.

ALTA SANTA MONICA CO.

606 Fay Bldg. Third and Hill Streets, Los Angeles.

REAL ESTATE HYPE. The Palisades Tract was compared to Burlingame near San Francisco in this advertisement, which ran in 1905. The language talks of a "bouquet of scenic charms," including the "verdant and picturesque Santa Monica Canyon," "the rolling foothills and mountain peaks," and the "ever changing grandeur of the mighty ocean in front." The private beach was considered a big attraction as well.

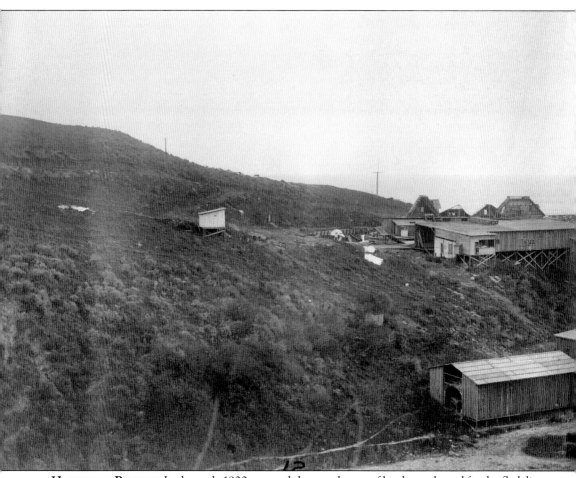

HOLLYWOOD PREVIEW. In the early 1900s, several thousand acres of land were leased for the fledgling movie industry in Santa Inez Canyon north of Santa Monica. Known as Inceville after Thomas Ince joined the New York Motion Picture Company, the site was used for silent films well into the 1920s. There were numerous natural backgrounds to choose from in the area—beach, ocean, hill, stream, and valley. The gorgeous scenery promoted the Santa Monica area effectively. Some

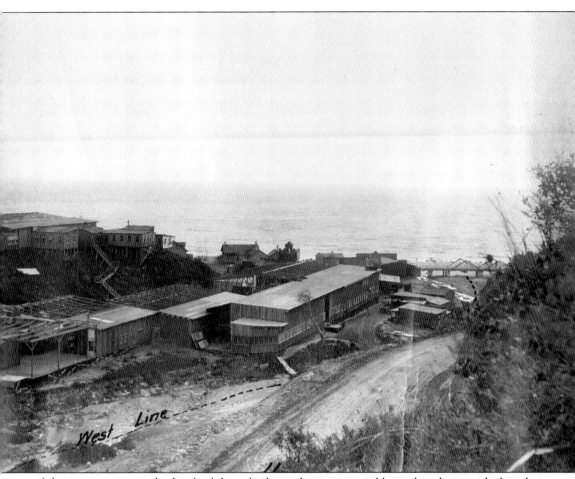

West Line

of the street scenes and other backdrops built on the site are visible in this photograph. Local residents often served as extras. Arthur Laurence Loomis described how he rode his paint pony while he was made up as a Native American in *Custer's Last Fight* in 1912. During one scene, he pitched spectacularly over his horse's head. Asked to repeat the fall for another scene, he refused to do it again. His unintentional pratfall is prominently featured in the film.

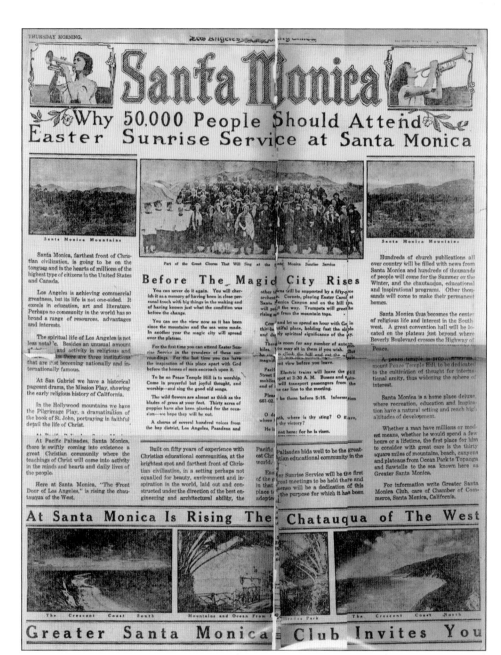

CHAUTAUQUA AT THE PALISADES. In 1922, this Sunrise Easter service advertisement served to promote the new Pacific Palisades community, which was just beginning. The copy plays heavily on its "Santa Monica" location and calls the new effort the "Chatauqua of the West." (Note the misspelling of Chautauqua.) The Pacific Electric trains left the Hill Street Depot at 3:30 a.m. in order to deliver worshippers to the site for the sunrise service. The Chautauqua movement started in 1874 on the shores of Lake Chautauqua, New York, as an educational summer camp for families. Speakers and entertainers were booked to lecture and give performances that were inspiring and uplifting. The environment was designed to be collegial. The first meeting of the founders took place in the Broadway Department Store Café in June 1921. In January 1922, nearly 200 of the 275 founders gathered to pick their lots in the new 1,100-acre tract.

24

PACIFIC PALISADES FOUNDERS. Rev. Charles Holmes Scott (right) was ordained as a Methodist minister in 1905 and held various pulpits during the next few years in Southern California. By the early 1920s, the Chautauqua movement in Southern California was rapidly outgrowing its facilities in Huntington Beach and Long Beach. Dr. Scott was tasked by Bishop Adna W. Leonard to find a new permanent location for the growing organization. Scott explored various possibilities and involved a number of prominent businessmen with the project. Several pieces of land were considered, but the final choice was the mesa above the bluffs north of Santa Monica. He formed his organization and called it the Pacific Palisades Association, which played on the already established name. A distinguished group of 25 Angelino businessmen were picked as trustees. Many of these men were already developers in the area, including R. C. Gillis, Albert Joseph Wallace (below), Walter L. Armacost, Charles Clarke Chapman, and Andrew M. Chaffey.

TRUSTEES OF A MOVEMENT. The ambitious goal of the Pacific Palisades Association was to create a permanent site for the Chautauqua movement in Southern California that would be one of the largest church centers in the world. The group planned to invest $4 million to make the center similar to the centers at Chautauqua Lake, New York, and Winona Lake, Indiana. William H. Carter was the business manager for the project (below). Oren R. Waite (left) was the educational director. Though the Methodists were instrumental in its founding, the Pacific Palisades was conceived as a nonsectarian community open to everyone.

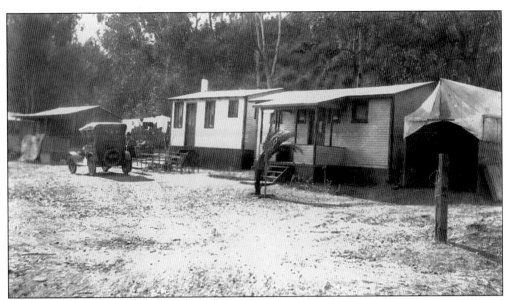

THE SITE. Once the site had been decided on, Dr. Charles H. Scott was faced with numerous issues. One was the group of squatters who had taken root on the land over the years. This photograph was sent in a letter to R. C. Gillis to illustrate the problems.

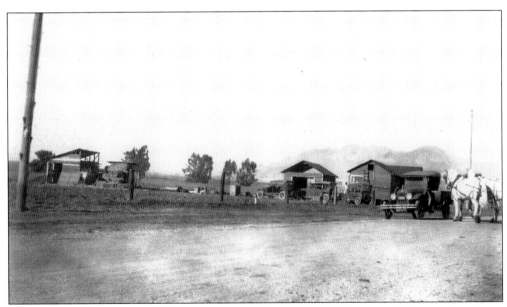

SHANTYTOWN. Primitive shacks and barns were built in Temescal Canyon over the years by tenants and Los Angeles residents fleeing the city's heat. The Pacific Palisades Association intended to subdivide its new purchase into residential lots in addition to its Chautauqua facilities. Originally the founders were able to lease these lots for 99 years and build homes. Later the leasing policy was dropped in favor of selling the lots.

ADVERTISING PARADISE. An early advertising brochure touts the improvements that the Pacific Palisades Association has made in its development, including cement sidewalks and curbs, Los Angeles city water, electricity, and gas. It also promotes the motor coaches that connect the area to Los Angeles. Lots can be purchased for as little as 20 percent down.

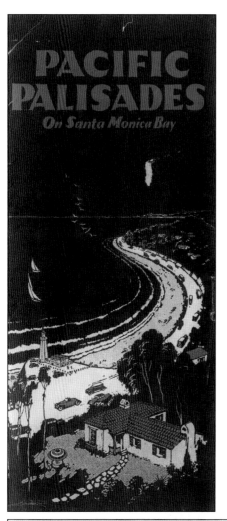

SUBDIVISIONS. This map, part of the brochure pictured at left, shows the geography of the newly subdivided Pacific Palisades. The Santa Monica Canyon separates the new community from the older community of Santa Monica. Beverly Boulevard (soon to be renamed Sunset Boulevard) connects the area to the rest of Los Angeles. It was completed ion 1935. The street layout of the Pacific Palisades is clear and has changed little over the years.

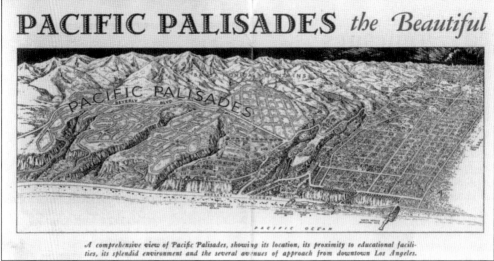

A comprehensive view of Pacific Palisades, showing its location, its proximity to educational facilities, its splendid environment and the several avenues of approach from downtown Los Angeles.

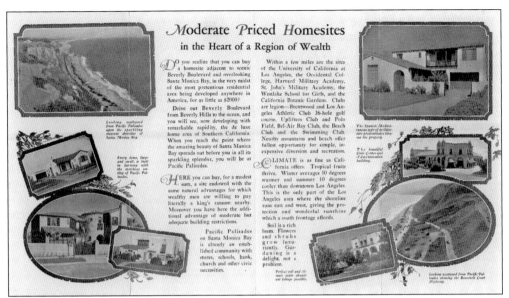

THE HOMES. The inside of the brochure shows the emphasis placed on affordability, proximity to other Los Angeles landmarks, and the climate. Homesites were available for as little as $2,000. Even the suitability of the land for flowers and shrubs is mentioned.

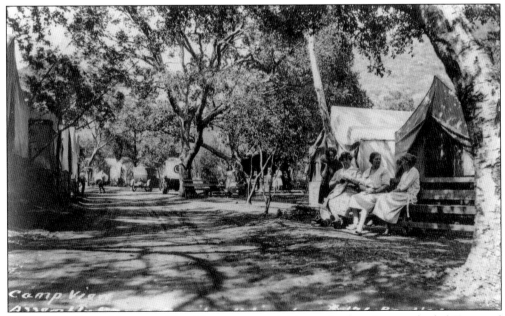

METHODIST CAMP MEETING. The Chautauqua activities took place in tree-shaded Temescal Canyon. This photograph shows a group of women socializing in front of one of the tents set up for members to use. Other buildings included a library and rustic casitas. (Courtesy of Security Pacific Collection/Los Angeles Public Library.)

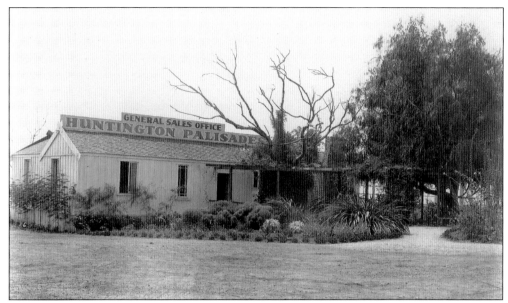

THE HUNTINGTON. The land that Abbott Kinney purchased was once again for sale in 1925. The Pacific Palisades Association decided to purchase the land, open a sales office, and add it to the growing residential operation. By purchasing the land, the association was able to prevent it from being sold to the Catholic Church for a private college. The college was located instead in Brentwood—Mount St. Mary's College—and the land on the mesa became the upscale Huntington Palisades residential district.

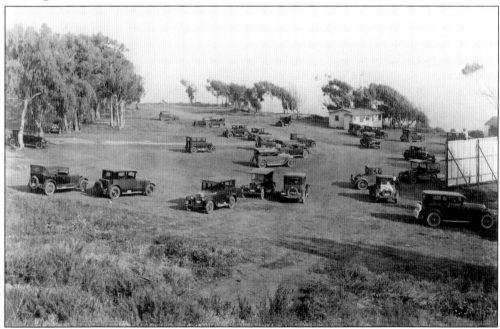

OPENING DAY. Cars are parked on the mesa above the palisades in preparation for opening-day festivities for the Huntington Palisades. Note the billboard at the right of the picture. It was one of several erected to promote the area. The signs were visible to drivers on the Coast Highway for miles.

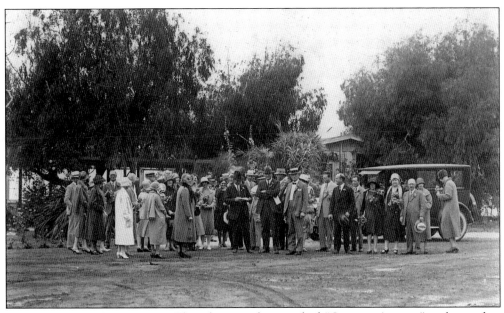

MARKETING THE SUBDIVISION. This photograph is marked "Governor's party" and records a gathering of prominent business people being shown the Huntington property. It was taken in June 1926. The subdivision was being promoted as an upscale area with wide curving streets and underground utilities. Financial difficulties led to R. C. Gillis forming the Pacific Land Corporation in 1928 to take over the development and complete it.

REAL ESTATE HYPE. This brochure extols the beauty of the Huntington Palisades and shows the ways it can be reached from Los Angeles. The prices are described as reasonable—$3,000 for a 75-foot frontage and $20,000 to $25,000 for larger lots. Improvements, which included 60-foot-wide streets, landscaping, and other amenities, cost more than $1 million (over $12 million in today's dollars).

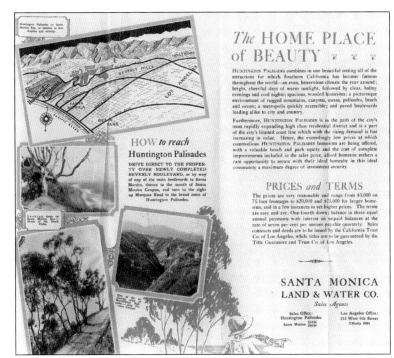

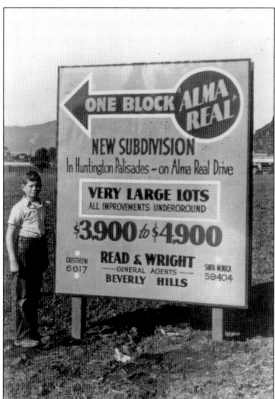

ONCE UPON A TIME. The prices listed on this sign for the Huntington Palisades seem like a fairy tale today, but in the 1950s, when this photograph was taken, lots were selling in this range. Note the open land behind the sign. There were many lots to choose from. The area languished during the Great Depression and World War II but began to grow again in the 1950s.

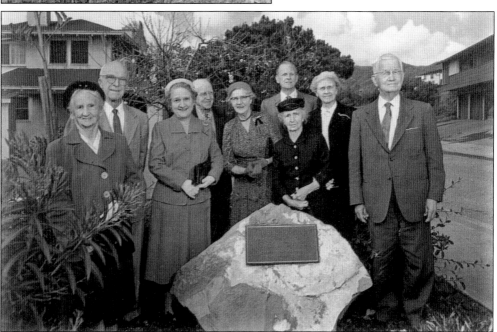

THE FOUNDERS. Taken in 1958, this photograph shows a group of the original founders still living in the Pacific Palisades. Many of the original group who bought lots in the 1920s lived their entire lives in the Pacific Palisades, watching it grow from a dream to a reality.

Three

THE BEACHES
ROLLING WAVES AND SAND

THE INCLINE.
Taken in the
early 1900s, this
photograph shows
Frances Gillis
(left), the wife of
R. C. Gillis, and
her friend enjoying
the private beach
below Adelaide
Drive. On the cliff
behind them, the
incline built by
the developers to
give access to the
beach is visible.
The beach shortcut
was only used for
a short period
of time because
of the difficulty
in obtaining
insurance. A steep
set of steps replaced
the incline.

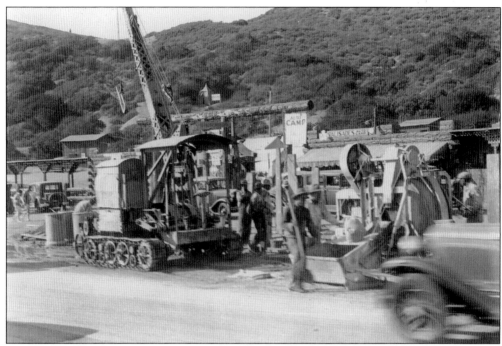

SEWERS AND HIGHWAYS. Workers in 1930 are trenching the Coast Highway for a sewer line. Behind their equipment are signs for the Palisades Auto Camp, operated by George Dunbar. Motoring up the coast was a popular pastime for Angelinos once the automobile became common. Auto camps were frequently seen along the coast, providing a place for motorists to stop overnight near the beach.

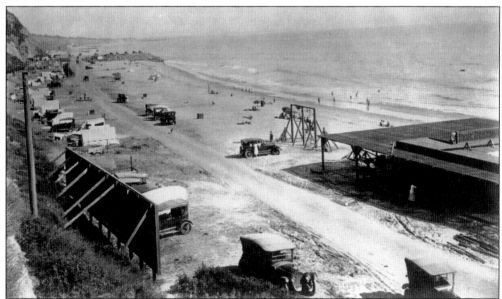

SUMMER DAYS. The beach has always been an important part of the Pacific Palisades. This photograph shows a summer day in 1923 or 1924. The Long Wharf is just a memory, leaving behind a pile of stones at the top of the photograph. Campers have pitched tents across the road and on the beach. The Pacific Palisades Bath House is located at the right of the picture.

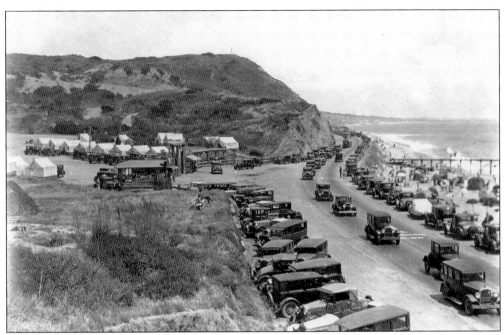

CAMPING AT THE BEACH. This is a 1930 view of the Palisades Auto Camp. The Coast Highway—known at this time as the Roosevelt Highway—is busy with motorists looking for parking, and the beach is covered with bathers. Camp owner George Dunbar received 15 percent of the fees the auto camp generated, and the Pacific Palisades Association received the balance.

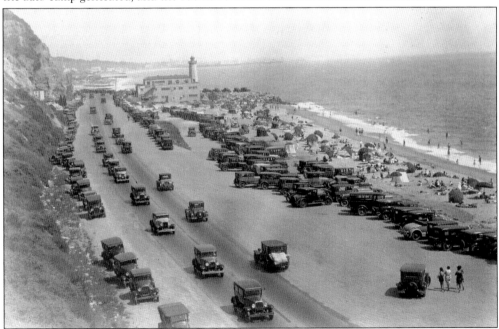

BATHING BEAUTIES. More cars and less parking characterize this summer day on the Coast Highway. The Pacific Palisades Bathhouse has given way to the Lighthouse, which doubles as a bathhouse and a restaurant. The Lighthouse site was sold to Will and Betty Rogers in the early 1930s. Betty Rogers eventually gave the site to the state, which named it the Will Rogers State Beach.

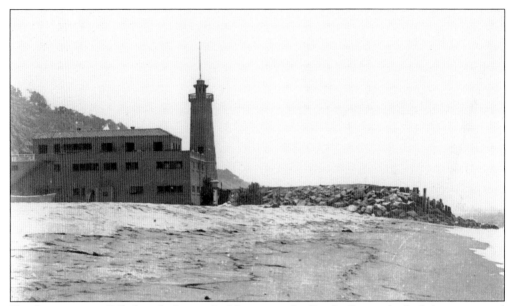

THE LIGHTHOUSE. Billed as the largest bathhouse on the Pacific Coast, the Lighthouse opened in 1927. Built by the Pacific Palisades Association on the base of the Long Wharf at Potrero Canyon, the bathhouse could accommodate 500 patrons and boasted its own laundry plant and a restaurant. The lighthouse was a working beacon, and its beach was free.

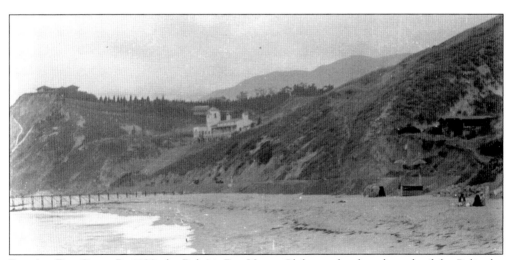

BEL AIR BAY CLUB. By 1930, the Bel Air Bay Upper Club was developed north of the Palisades Auto Park. It was built in 1927 by Alphonzo Bell as part of a 30-acre development. The upper club is paired with a lower club on the opposite side of the Coast Highway that included beach cabanas and paddle tennis courts.

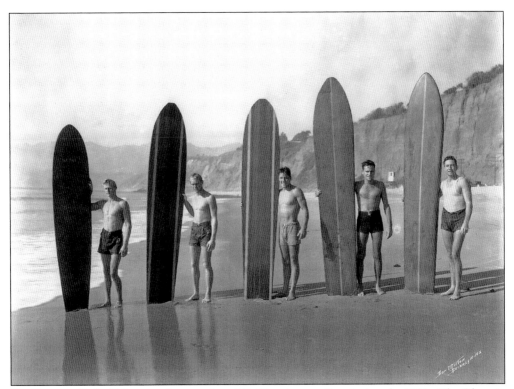

BIG BOARDS. Duke Kahanamoku introduced California to surfing during the 1920s. The Olympic medalist in swimming was an excellent surfer, and he gave exhibitions after he retired from the Olympics of the new water sport. This photograph shows surfers on Pacific Palisades Beach. Their heavy, large wooden boards are similar to the ones popularized by Kahanamoku.

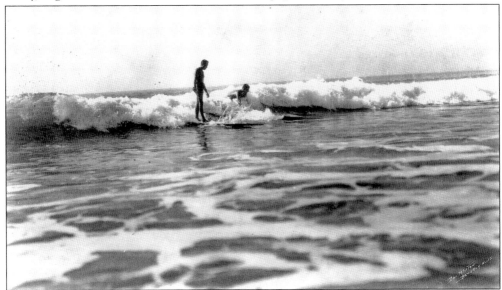

SURF'S UP. Waves, beaches, boogie boards, and surfboards are constants for Pacific Palisades residents. The children grow up swimming at the beach and learn to enjoy water sports at an early age. This photograph was part of the sales materials used to promote the Pacific Palisades.

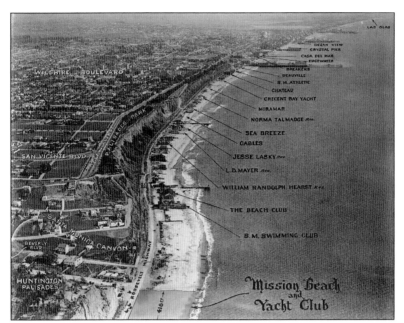

THE GOLD COAST. Celebrities and movie stars flocked to the beach below Palisades Park and built homes. This advertising brochure shows the residences of many well-known movie stars and prominent Angelinos, as well as the location of the beach clubs—many of which still exist.

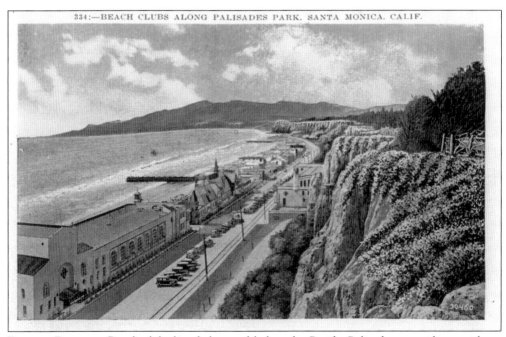

PRIVATE BEACHES. Beach clubs lined the sand below the Pacific Palisades, providing residents and guests with beach-going facilities. The Beach Club, the Jonathan Club, and several others were part of the Gold Coast ambiance. This postcard shows the edge of Palisades Park and the view up the coast.

Four

THE STREETS
MINES, MINISTERS, AND ALPHABETS

NAMESAKE. Adelaide Drive along the edge of the Santa Monica Canyon was named for Adelaide Gillis, daughter of R. C. Gillis, when the Palisades Tract was developed. Here she poses for a photograph on the fence across the street from her father's craftsman-style home located at Fourth Avenue and Adelaide Drive.

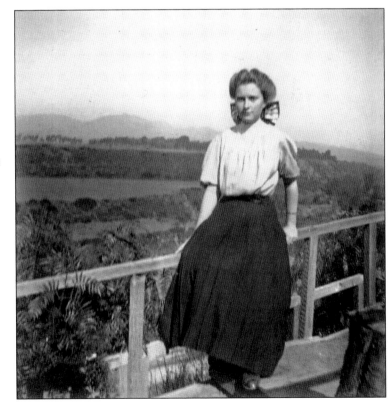

HORSE POWER. Many of the residences along Adelaide Drive were used as summer homes for Los Angeles residents. It was a dusty buggy ride in the early 1900s to relocate for the summer, bringing ponies, children, and pets. Some who made the trek included Catholic archbishop John Joesph Cantwell, architect John Farquhar, Robert Jones (nephew of Sen. John P. Jones), Arthur Fleming, and Harry Gorham.

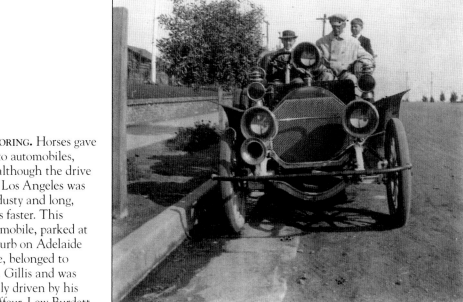

MOTORING. Horses gave way to automobiles, and although the drive from Los Angeles was still dusty and long, it was faster. This Locomobile, parked at the curb on Adelaide Drive, belonged to R. C. Gillis and was usually driven by his chauffeur, Lew Burdett.

FIRST DAUGHTERS. The developers of the Palisades Tract immortalized their families by naming the streets for their daughters and nieces. Marguerita Drake was the niece of Arcadia Bandini de Baker. Georgina Jones was the daughter of Sen. John Jones. Adelaide Gillis was the daughter of R. C. Gillis. Pictured here are Ollie Paulin, Marguerita Drake, Lindsay Gillis, Genevieve Wilcox, Helen Thayer, and Dorothy Gillis.

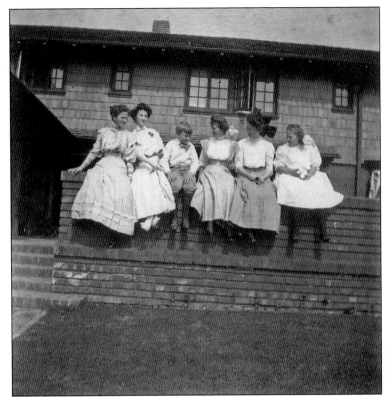

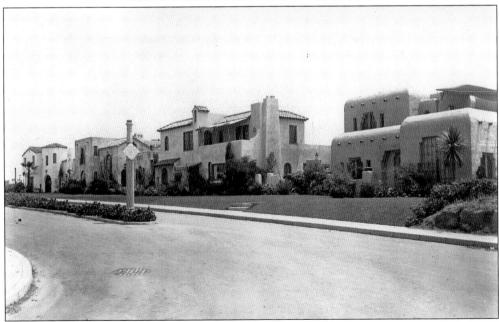

ADELAIDE DRIVE, 1925. By the early 1920s, the craftsman-style bungalows of the early residents had given way to Spanish Colonial Revival architecture. The improvement in the roads, the automobile, and the growth of Los Angeles had changed the area from summer residences to homes built for year-round living.

41

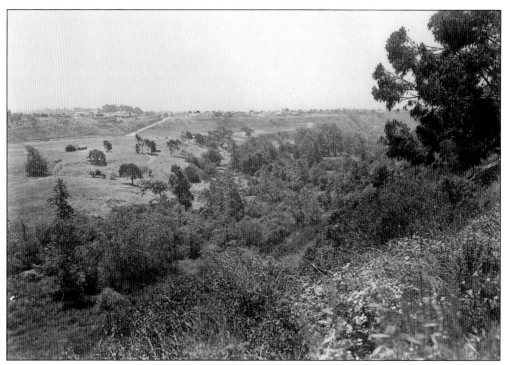

SEVENTH STREET. Adelaide Drive crowns the hill above Santa Monica Canyon, and Seventh Street descends into the Santa Monica Canyon. At one point, there was talk of bridging the canyon with something like the Colorado Street Bridge that spans the Arroyo Seco in Pasadena. However, nothing came of these plans. The Seventh Street Hill is still one of the main access routes from Santa Monica to the Pacific Palisades.

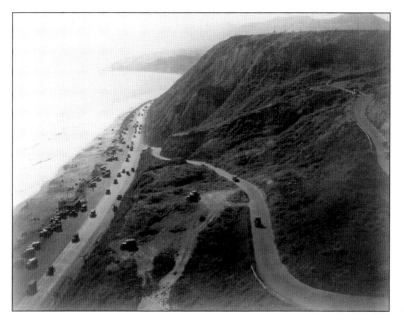

THE COAST HIGHWAY. Via de la Paz (Street of Peace) was a major point of access to the Pacific Palisades during the early years. The street ran from the beach to the center of the community. In the 1950s, the access to the beach was blocked by a series of landslides.

ARCH ROCK.
In 1906, this picturesque rock formation on the coast road collapsed. Rumors swirled that the arch had been dynamited during the night to make way for the new Roosevelt Highway. Others claimed it broke apart due to wind and rain. Its demise left the way open for the new road to be wide enough for the new automobiles.

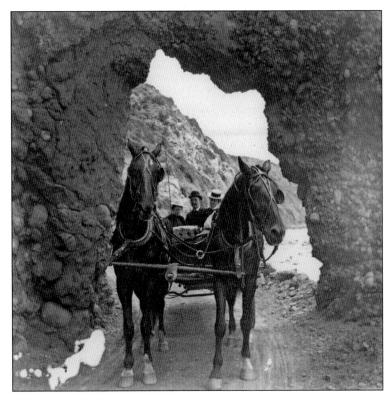

MARQUEZ AVENUE. When development began, the mesa above the Palisades was accessed by a road along the northern edge of the Santa Monica Canyon. Called Marquez Avenue after the family that owned the Rancho Boca de Santa Monica, the street wound its way up the hill to the mesa.

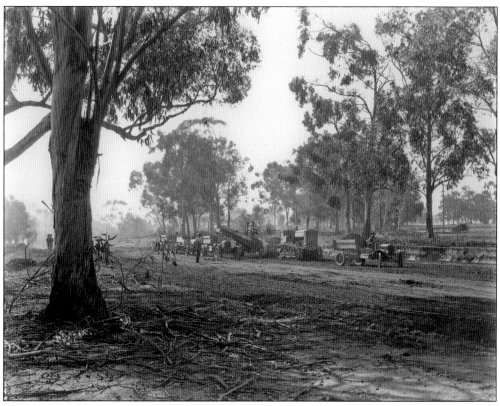

Chautauqua Boulevard. With the opening of Beverly Boulevard (later Sunset Boulevard), Marquez Avenue was also widened and improved to provide better access to the fledgling Pacific Palisades community. To reflect its new status and the focus of the new community, the street was renamed Chautauqua Boulevard. In 1929, the Pacific Land Corporation attempted to have the street name returned to Marquez Avenue but was turned down by the city.

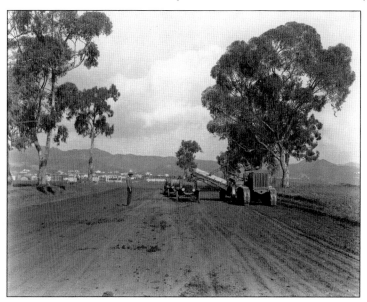

Grading the Roads. The Pacific Palisades expected to grow and designed its streets accordingly. Chautauqua Boulevard was graded to be a wide street that intersected with the newly paved Beverly Boulevard. The developing neighborhood known as the "Alphabet Streets" is visible in the background.

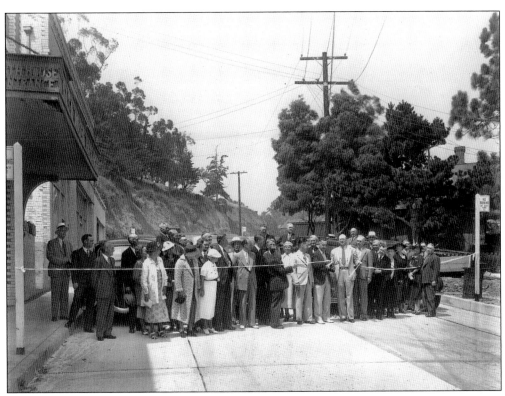

WIDENING THE BOULEVARD. By 1937, Chautauqua Boulevard needed widening to serve the growing Pacific Palisades community. This group has gathered near the end of the road where it meets the Coast Highway to cut the ribbon on opening day of the newly refurbished road. Chautauqua Boulevard is still a major access road into the Pacific Palisades. Note the women in the tree on the right of the picture.

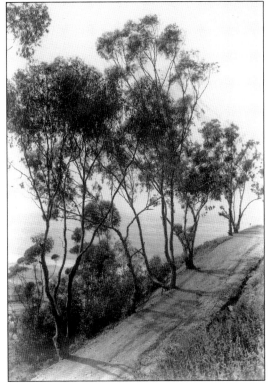

EARLY MESA ROADS. This early dirt road hugs the bluff of the Palisades above Santa Monica Canyon. It would have provided access for those who had built shacks on the bluff and was perhaps part of Abbott Kinney's proposed development on what is now the Huntington Palisades. The trees are young eucalyptus.

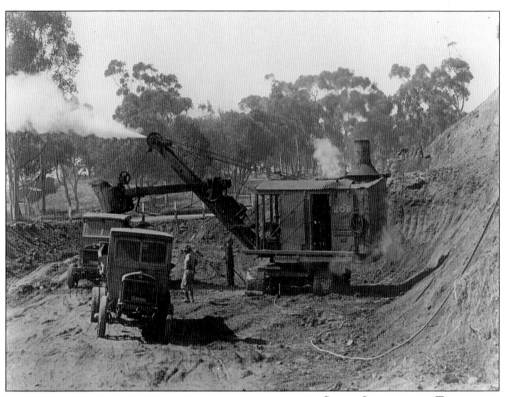

STEAM SHOVELS AND TRUCKS.
By 1926, road building had
progressed beyond mules and
drags to steam shovels and
motorized trucks. This crew is
cutting the bluff to widen the
early road in order to create
Corona del Mar (Crown of the
Sea). This street was a major new
road along the edge of the new
Huntington Palisades subdivision.

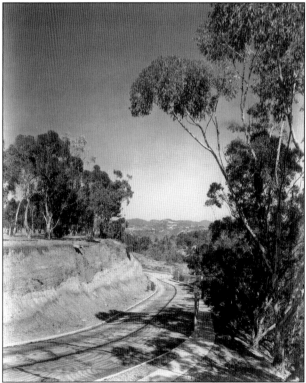

CORONA DEL MAR. The
Huntington Palisades was
developed from day one to be
an upscale neighborhood with
60-foot-wide streets, sidewalks,
curbs, and decorative lighting.
In this early view, Corona del
Mar winds its way up from
Chautauqua Boulevard to the
edge of the Palisades. No homes
have been built on Toyopa
Drive–the street barely visible
to the left of the photograph.

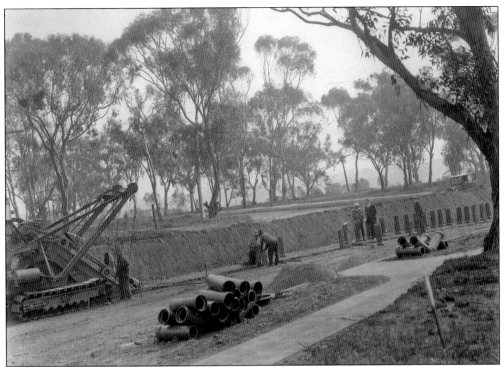

SEWERS AND SIDEWALKS. This is another view of the street construction creating Corona del Mar. A machine assists a work crew in placing clay sewer pipe below the road. Note the car on the right that is barely visible over the dirt.

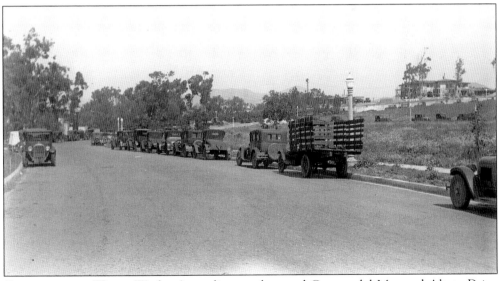

CONSTRUCTION WORK. Workers' cars line newly paved Corona del Mar and Altata Drive (originally called Perote Drive). Altata Drive is named for a seaport in Sinaloa state, Mexico. All of the street names in the Huntington Palisades were assigned by W. W. Williams, the engineer for the project. He picked names based on his experiences as a mining engineer in Mexico and South America.

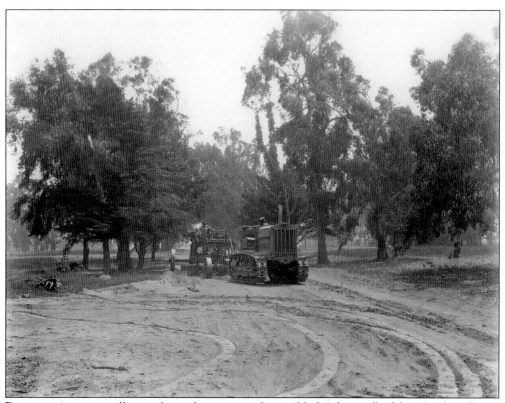

BLADING. A tractor pulls a grader as these two workmen "blade" the roadbed for Almoloya Drive. Obviously great care was taken with the development of the Huntington Palisades in order to preserve the trees and the contours of the land.

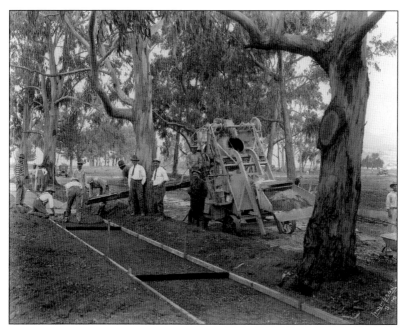

CEMENT MIXING. A cement mixer turns as workers pour the sidewalks along Almoloya Drive in this 1926 photograph. The houses of the early residents of the Alphabet Streets can be seen in the background to the right.

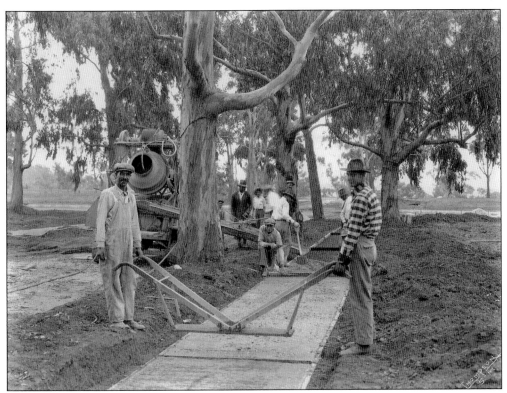

LEVELING. Workers level the newly poured cement sidewalk on Almoloya Drive. The Pacific Palisades Association developed 226 lots in the Huntington Palisades. The early investment in top-quality infrastructure continues to pay dividends for today's homeowners, who enjoy a picturesque neighborhood and rising property values.

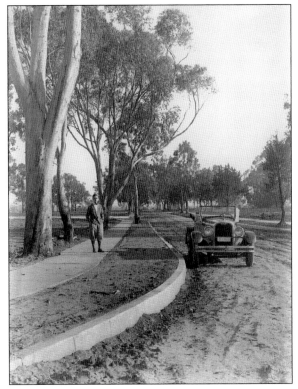

ALMOLOYA DRIVE. The curbs are in, but the new street is not yet paved. Almoloya Drive is named for a town in Chihuahua, Mexico. The street was originally named La Luz. Robert Gillis Bundy, the son of Charles LeRoy Bundy, has parked his car near the curb and poses on the newly poured sidewalk.

49

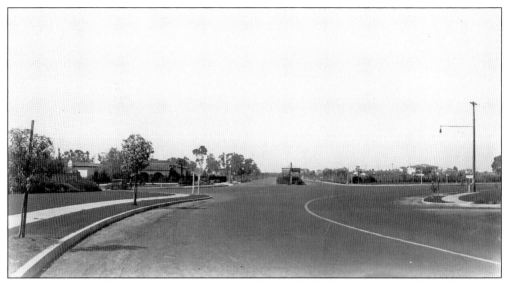

INTERSECTIONS. Pampas Ricas, Chautauqua, and Sunset Boulevards all come together in a grand convergence of thoroughfares. Pampas Ricas, a 100-foot-wide street, was named after a ranch engineer W. W. Williamson had known in Patagonia, Argentina. At the time this photograph was taken, the tract office for the Huntington Palisades (left) was operational, and Sunset Boulevard was still called Beverly Boulevard.

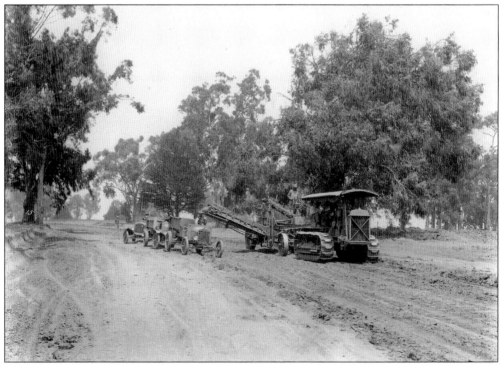

GRADING ALMA REAL DRIVE. The words mean "Royal Soul," but the street is named for a Mexican singer popular during engineer W. W. Williams's time in Mexico. She was a friend, and he gave her name to the street that forms the western edge of the Huntington Palisades. In later years, she visited the area and had her picture taken on the street.

50

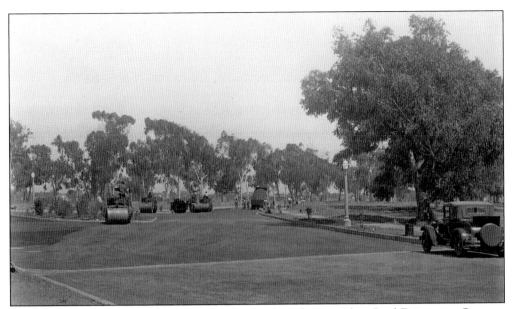

PAVING ALMA REAL DRIVE. Workers put the final touches on Alma Real Drive near Ocampo Drive. Note the decorative "Lightoliers," as they were called in the 1920s. New street trees have been planted between the street and the sidewalk. Kinney's trees remain. In 1928, construction company Braun, Bryant, and Austin agreed to pave the roads in the Huntington Palisades. They charged 13¢ per square foot.

ALMA REAL DRIVE AT ALTATA DRIVE. Most of the corners in the Huntington Palisades are sweeping curves. This photograph shows the same area that is under construction in the image on the bottom of page 47 some years later. The trees and grass have grown, but there are still few homes constructed in the subdivision. The photograph was probably taken sometime in the early 1930s as the Depression began to hammer real estate sales and construction.

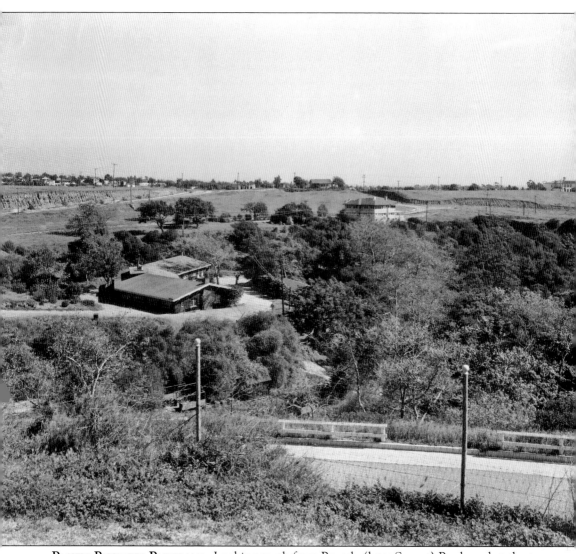

PACIFIC PALISADES PANORAMA. Looking south from Beverly (later Sunset) Boulevard at the top of Temescal Canyon, the Pacific Palisades is sparsely settled. The buildings on the horizon are on Via de la Paz, which stretches to the beach in the distance. The building with the square tower is the Methodist church, and the other building is the Pacific Palisades elementary school. The

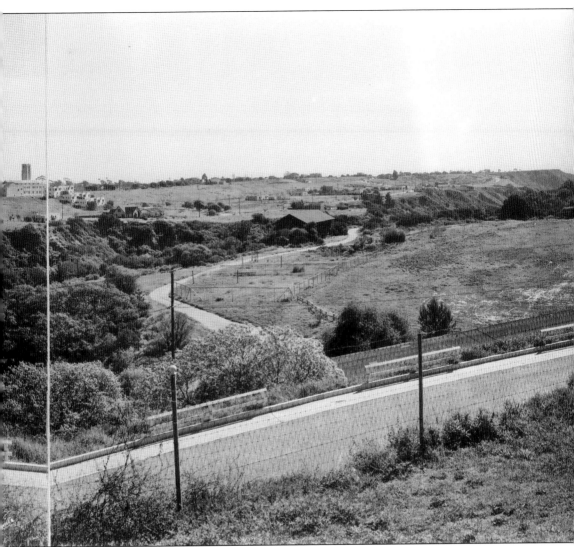

square building on the left is Harmony Hall, and the building in the foreground is the dining hall used by the Pacific Palisades Association during its Chautauqua meetings. The houses on the ridge are some of the original homes built on the Alphabet Streets.

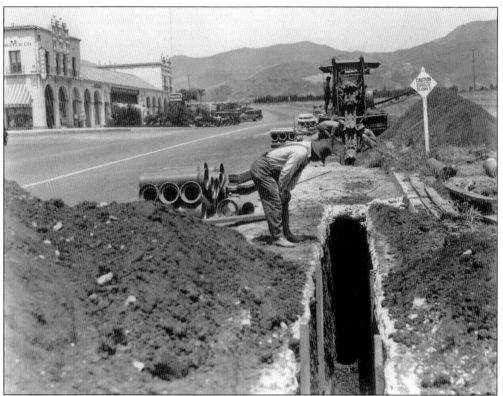

TRENCHING BEVERLY BOULEVARD. In June 1930, workers are digging up Beverly Boulevard in order to lay sewer pipe. The Business Block is on the left, and there are many autos parked in front. There are only a few other buildings in the center of town at this point. The property across from the Business Block had been rezoned for commercial use the year before.

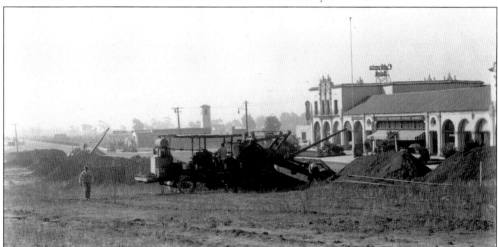

BEVERLY BOULEVARD. Looking from the other direction, the trencher is obviously a complicated piece of machinery. The Business Block has a California Bank sign on its roof and the center of the building in this 1930 photograph is Nelson's Palisades Public Market. There is drugstore on the corner, which was owned at this time by Irvin M. Gorsuch, who paid $60 a month in rent plus five percent of his receipts to the Pacific Land Corporation.

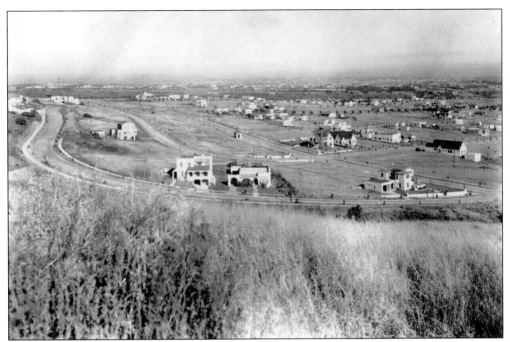

THE ALPHABET STREETS. The section of the Pacific Palisades north of Beverly Boulevard (Founders' Tract 1) was laid out in smaller lots on a grid that became known as the "Alphabet Streets." Each street on the grid was named for a religious leader in alphabetical order. This photograph shows the small bungalows that were constructed in this area.

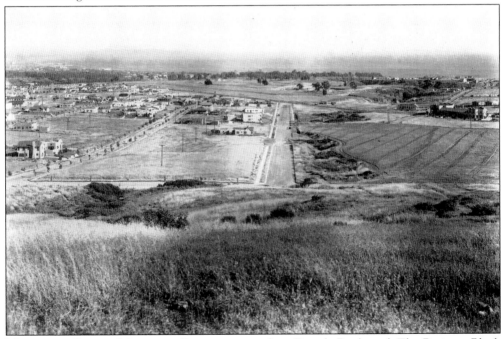

MONUMENT STREET. Monument Street cuts a path to Beverly Boulevard. The Business Block is visible on the right; Embury Street is on the left side of Monument Street. This late-1920s photograph was probably taken from above Bestor Street visible in the foreground.

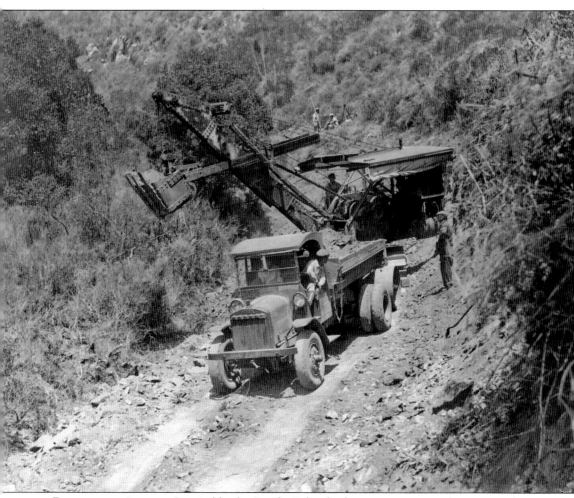

BIENVENEDA AVENUE. Inevitably the Pacific Palisades began to move to the west, and more roads were cut into the canyons. This early steam shovel is clearing a path for the construction of Bienveneda Avenue up Las Pulgas Canyon in 1930. George E. Barrett Jr. built his mansion, designed by John Byers, in this area in 1935. Later his estate became St. Matthews Episcopal Church and School.

Five

THE NEIGHBORHOODS
COMMUNITY AND FAMILY

THE EVENING NEWS, WEDNESDAY, JUNE 6, 1906.

PALISADES

Unique — Distinctive — Different

Majestically situated on a towering bluff.

An ocean vista unsurpassed for its magnitude and grandeur.

Highly elevated SOIL, with ocean-side advantages.

Located between charming Santa Monica canyon and progressive Santa Monica.

Woodland grandeur, mountain scenery, the ocean, metropolitan improvements—where will you find a better combination of residential elements?

Palisades is the ocean terminus of the great San Vicente boulevard and is conceded to be the most desirable residence property between Hollywood and the sea.

Visit the "only western rival of Palisades-on-the-Hudson" tomorrow.

See the most fascinating type of property in Southern California.

For maps, handsome souvenir booklets, and all "inside information," see

R. B. Dickinson
A. C. Dezendorf

331 South Hill Street, So's Los Angeles Agents Both Phones ss

Santa Monica Agents
W. T. Gillis and Roy Jones
egon Avenue

No Lots Less Than

100x200

...Feet...

Fertile soil; a profusion of Flowers
40 minutes from Los Angeles Pacific Cars

Cement curbs and walks, water, gas, sewers and electricity. Unexcelled bathing privileges. Handsome residences now being built.

LARGE LOTS INTENDED. The Palisades Tract was intended to be a neighborhood of homes on large lots with proximity to the ocean. The area may have been "40 minutes" from Los Angeles by Los Angeles Pacific Cars, but it was a dusty daylong buggy ride for the residents who made the area their summer homes. Note the reference to the "Palisades on the Hudson" in this 1906 advertisement.

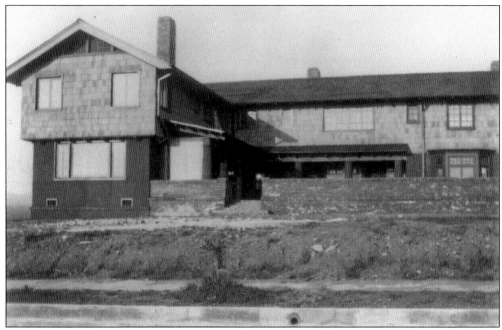

CRAFTSMAN BUNGALOWS. The early homeowners in the Palisades Tract often built craftsman-style bungalows like the Gillis home under construction in this photograph. Designed by Myron Hunt and Elmer Grey, the house was conceived of as a summer home with an outdoor orientation, open courtyards, and windows looking over the ocean view. It has been designated a Santa Monica Historical Landmark.

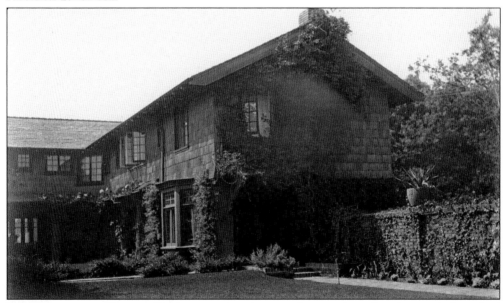

LANDSCAPING AND SHAKES. By the time this photograph was taken, the vines and plants had grown significantly, softening the edges of the house. The shakes were brown and the floors were red terra-cotta tiles according to an article published in a contemporary magazine. The interior woodwork was redwood that was stained a warm brown color. The Palisades Tract includes some 126 properties in an 18-block area. It is still a desirable residential neighborhood.

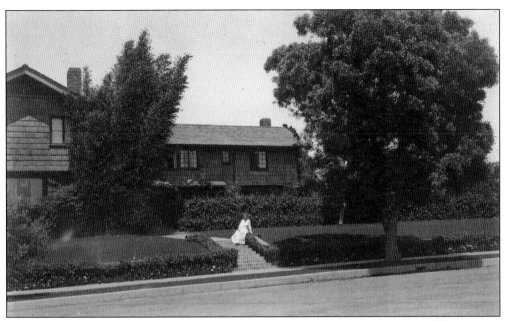

ADELAIDE ON ADELAIDE DRIVE. By the time this photograph was taken around 1915, Adelaide Drive was a settled neighborhood with trees and grass. Adelaide Gillis, aged about 20, sits on the walk looking out over the canyon and the street named for her when she was 10.

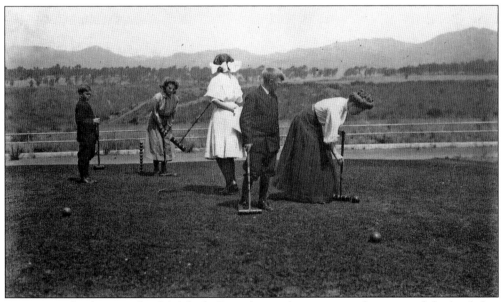

CROQUET. The front yards of Adelaide Drive homes have spectacular views of the land that became the Pacific Palisades. Without television or even radio, families often gathered on lawns to play games like croquet. Obviously the concept of California casual for outdoor activities had not yet taken hold.

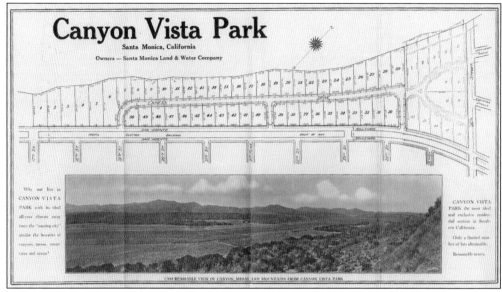

CANYON VISTA PARK. This subdivision sits on the rim of the Santa Monica Canyon north of Adelaide Drive. It has dramatic views of the Pacific Palisades and the Riviera. Developed in the early 1920s, its streets are shaded by its original Moreton Bay fig trees. Note the grove of lemon trees located on what became the Riviera Golf Course.

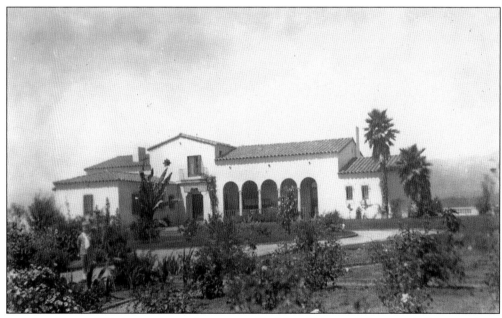

LA MESA DRIVE. This house sits on the corner of La Mesa Drive and Nineteenth Street and was one of the first houses built in Canyon Vista Park. The house is located just above the Riviera Golf Course. A favorite pastime of the children who lived here was to throw firecrackers down on the greens and ruin the golfers' shots.

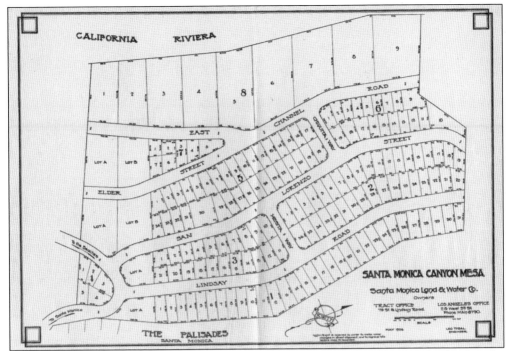

SANTA MONICA CANYON MESA. R. C. Gillis bought some of the Marquez family's land in the Santa Monica Canyon. Eventually the area was subdivided into the Santa Monica Canyon Mesa. One of the streets was originally named Lindsay Road after Gillis's son. However, the post office rejected the name, and the road was renamed Kingman Avenue.

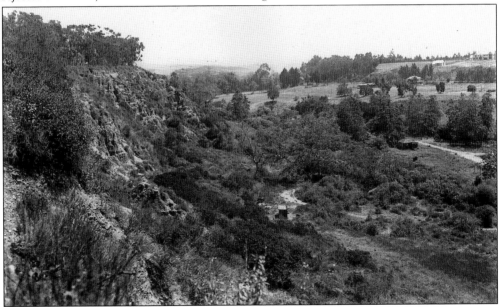

BEFORE THE BULLDOZERS. This area of Santa Monica became the Canyon Mesa subdivision in the early 1920s. There are several shacks scattered among the trees, as well as more substantial homes. The subdivision is connected to Santa Monica by the Seventh Street hill and to the beach by Entrada Drive.

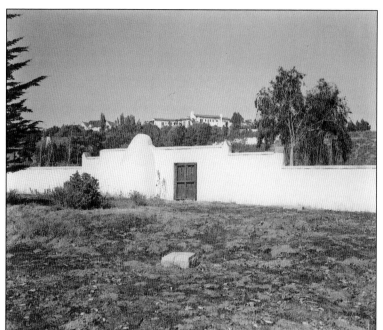

MARQUEZ FAMILY CEMETERY. The Marquez family set aside land for a cemetery in the Santa Monica Canyon, and more than 30 members of the family are buried there. This photograph, taken in July 1937, shows the wall the Santa Monica Land and Water Company commissioned John Byers to construct around the cemetery in 1927 when it was subdividing the Canyon Mesa tract.

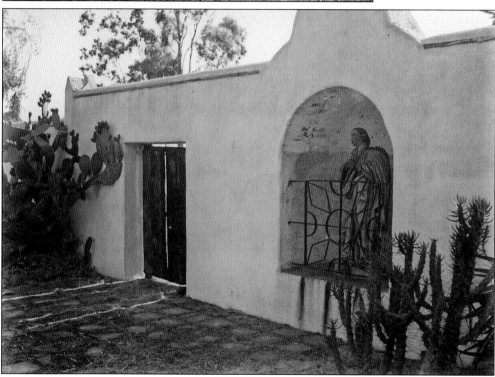

SAN LORENZO. The cemetery is located on San Lorenzo Street, and Dorothy Gillis installed this statue of San Lorenzo in the shrine after the wall was constructed in 1927. The Santa Monica Land and Water Company tried unsuccessfully to deed the cemetery to the Catholic Church so that it could be maintained. Ultimately the company quitclaimed it to Pedro and Aurora Marquez. It remains under Marquez family control and is a registered historical landmark.

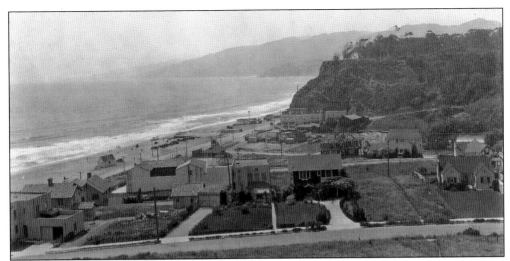

SANTA MONICA CANYON. The mouth of the Santa Monica Canyon has given way to houses and buildings in this photograph taken sometime in the early 1920s. The Long Wharf is gone, and the Huntington Palisades has not yet started. The road going up the hill is still Marquez Avenue (later Chautauqua Boulevard). Many of these buildings remain in the canyon today.

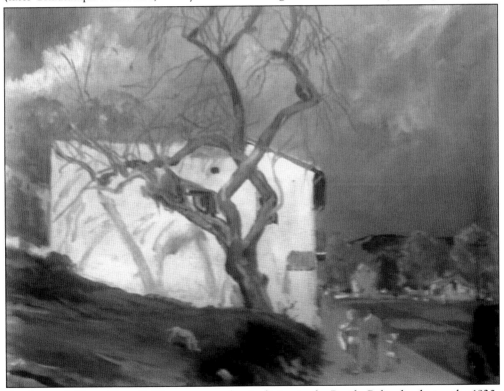

AN ARTIST'S VIEW. Hugo Ballin was a noted artist living in the Pacific Palisades during the 1930s and 1940s. His murals grace the Observatory in Griffith Park and the B'nai B'rith Temple. He was also a well-known film director with a number of silent movies to his credit. This painting shows a family walking back from the beach in the Santa Monica Canyon. (Courtesy of the Loomis Family Collection.)

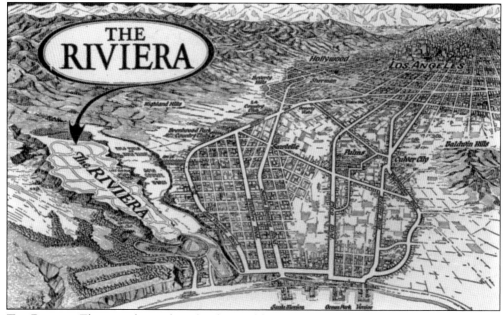

THE RIVIERA. This upscale Pacific Palisades neighborhood was designed to imitate the ambiance of the French and Italian Rivieras. The streets were named for towns in Europe—Amalfi, Napoli, and Corsica—and each street was landscaped to match its namesake. Underground utilities, bridle trails, and lots contoured to the land all helped to create this subdivision located adjacent to the Palisades Tract and the Founders' Tract 1 of the Pacific Palisades.

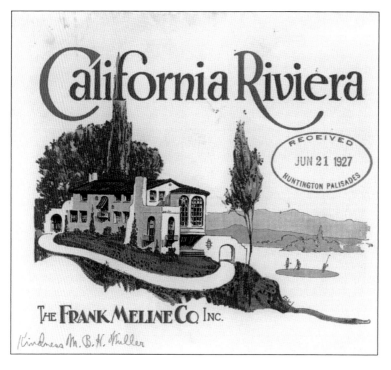

CALIFORNIA DREAMS WITH AN ITALIAN TWIST. This early brochure for the California Riviera development is a good example of the advertising designed in the 1920s. The Frank Meline Company was the selling agent and developer for the tract. Note the golfers to the lower right in the drawing. The famed Riviera Golf Course opened in 1927.

THE NEIGHBORHOOD. This part of the brochure describes the location of the Riviera in the real estate hyperbole of the day, "Six of our finest golf clubs are within ten minutes of the track, one adjoining. Six beach clubs are with ten minutes drive of the property."

Adjoining ~

Situated within the city limits of Los Angeles, and reached by Beverly Blvd., which follows along the hills from the Beverly Hills Hotel until it reaches the ocean.

Six of our finest golf clubs are within a few minutes of the tract, one adjoining. Six beach clubs are within ten minutes drive of the property. There are many beautiful mountain and canyon trails in and near the tract, where one may enjoy riding without being molested by automobiles. Convenient accommodations for the boarding of horses may be arranged nearby.

In fact, every wish for home life can be gratified without leaving the immediate vicinity of your home.

Restrictions ~

It is our desire and purpose to offer every possible protection to each purchaser. Plans for all homes must be submitted to and be approved by an architectural committee, whose duty it will be to see that the exteriors of all homes conform in architecture, and in keeping with the community requirements. No houses will be permitted to be moved onto the premises, and suitable setbacks have been provided to insure proper location of each residence. The restrictions provide that the cost of homes will range from a minimum of $12,500 to $25,000, depending on the location, and are in force until 1950, and continue automatically for 25-year periods thereafter until terminated by vote of property owners.

RESTRICTIONS. According to the restrictions created for the Riviera, the homes built there had to cost more than $12,500 and they had to be built with "suitable setbacks." The development formed an architectural committee to "see that the exteriors of all homes conform in architecture, and in keeping with the community requirements."

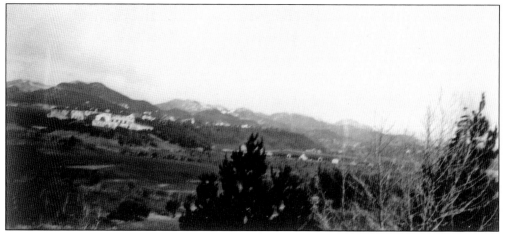

THE RIVIERA COUNTRY CLUB. Plans for the Riviera Country Club began in 1922 when Frank A. Garbutt, vice president of the Los Angeles Athletic Club, started a search for land on which to build a golf course. A syndicate was formed, and a deal was negotiated to purchase land in the Santa Monica Canyon from Alfonzo Bell. The clubhouse officially opened in 1928.

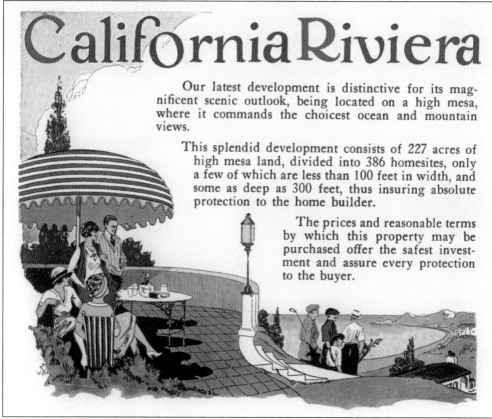

California Riviera

Our latest development is distinctive for its magnificent scenic outlook, being located on a high mesa, where it commands the choicest ocean and mountain views.

This splendid development consists of 227 acres of high mesa land, divided into 386 homesites, only a few of which are less than 100 feet in width, and some as deep as 300 feet, thus insuring absolute protection to the home builder.

The prices and reasonable terms by which this property may be purchased offer the safest investment and assure every protection to the buyer.

HOMESITES. Ocean and mountain views were free, but this brochure guarantees that the prices and reasonable terms offer the "safest investment and assure every protection for the buyer." Two hundred twenty-seven acres were to be developed into 386 home sites. Each lot was to be 100 feet wide, and some were 300 feet deep.

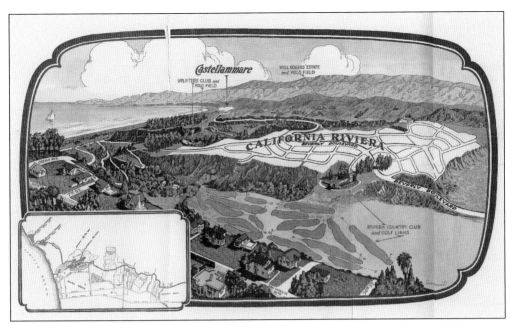

TRACT 8978, THE RIVIERA. This brochure shows the relationship between the new Riviera tract and other developments in the area. Uplifters Club, Will Roger's estate, and Castellammare are located at the top of the map. The Frank Meline Company was the selling agent for the tract. The map inset to the left shows the location of the University of California Southern Branch (UCLA) and a site for Occidental College, which was never built.

GOLF TOURNAMENTS. Crowds still gather on this hill to watch the golf matches as this group is doing sometime in the 1930s. The Riviera hosts a major PGA tournament each year, drawing major players and giving the residents a good view of their neighborhood from the blimp. The clubhouse is a graceful reminder of its roots in the 1920s. (Courtesy of the University of Southern California, on behalf of the USC Special Collections.)

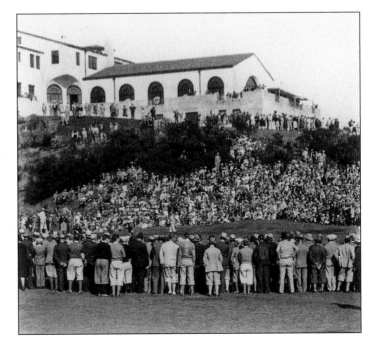

SULLIVAN CANYON. R. C. Gillis built his stable at the mouth of the Sullivan Canyon. When the horses needed to travel to horse shows, they were walked up the mesa and loaded onto railcars at San Vicente Boulevard. Sullivan Canyon is one of the last areas in West Los Angeles that allows horses and stables.

CANYON WEEKENDS. As Santa Monica became more built up, R. C. Gillis needed a new retreat from his busy life in Los Angeles. In 1923, he built this rustic cabin, the Sullivan Cabin, as a refuge from city life. The "Cabin" was used on weekends and as an informal gathering place for family and friends.

RANCH HOUSES. Tucked under the rim of the canyon, the Cabin was the centerpiece of several buildings, including an adobe house. A local farmer grew chives in the canyon, and Dorothy Gillis grew gladiolas for the flower market at the mouth of the canyon. In 1939, Cliff May purchased much of the Sullivan Canyon and began to subdivide it into housing sites.

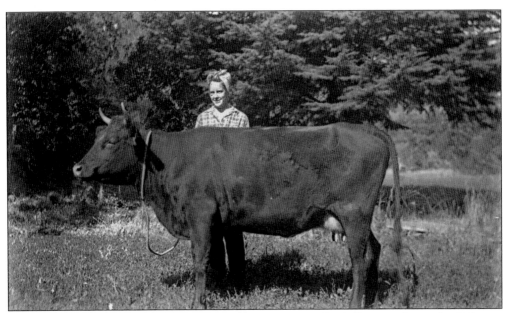

COWS AND VICTORY GARDENS. During World War II, Dorothy Gillis moved into the Cabin in Sullivan Canyon with her extended family. She planted a victory garden and grew vegetables to supplement the rationing imposed during the war. She also maintained a milk cow that provided dairy products for the family. The cow sometimes wandered into the chive fields, and the family remembers drinking onion-flavored milk for several days after her forays.

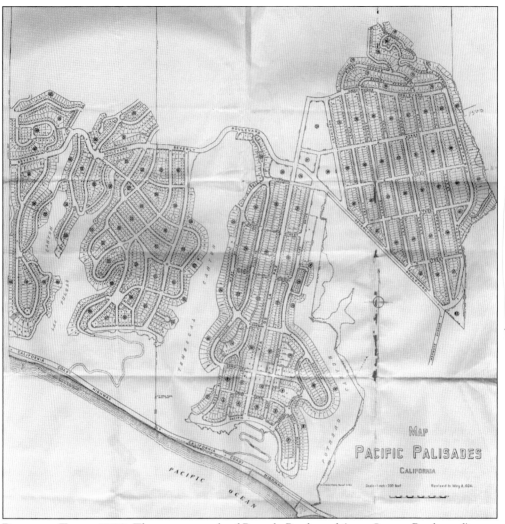

PALISADES TRACT 9300. The streets north of Beverly Boulevard (now Sunset Boulevard) were lined with narrow lots that were priced lower than the more substantial lots laid out below Beverly Boulevard and the Huntington Palisades. On this early map, the cross streets are still named A, B, C, and D, and the other streets on the grid are numbered.

FOUNDERS' TRACT 1. When the Founders' Tract 1 neighborhood was laid out, the narrow streets and small lots were intended to be affordable housing for retired clergy, missionaries, and widows. Founders' Tract 2, south of Beverly Boulevard, was laid out in larger lots and was intended to be more expensive.

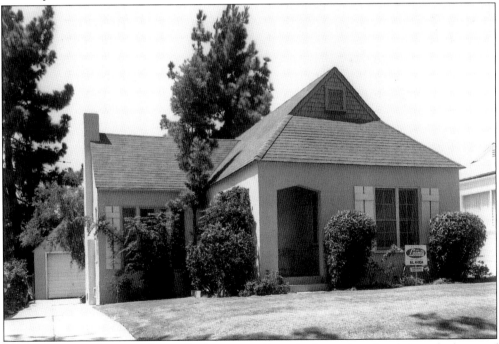

BUNGALOWS AND STUCCO. Originally the street grid was both numbered and given the letters of the alphabet as names. Eventually the streets were renamed for religious leaders in alphabetical order. The area became known as the Alphabet Streets. While the lots are still narrow, the prices are no longer modest.

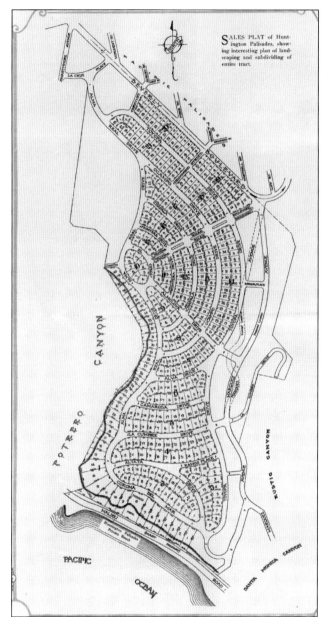

THE HUNTINGTON PALISADES. When he needed money for his Venice project, Abbott Kinney sold his mesa land for $25,000 to Frank N. Davis. Davis eventually sold the land to Collis P. Huntington, who intended to build a home overlooking the Long Wharf. However, Huntington died before the home could be built. Mount St. Mary's College was pursuing the site for their campus when the Pacific Palisades Association decided to purchase the land from the Huntington heirs to complete the subdivision of the mesa. The price paid was $1,625,000, or approximately $6,566 per acre. Unlike the grid that was used in Founders' Tract 1 and most other developments of the day, the Huntington streets were contoured to the land rather than as a formal pattern. There were no alleys, and arterial roads were placed at the perimeter of the tract to minimize cross-traffic. The tract's many innovations have become standard in subsequent developments but were radical departures in the 1920s.

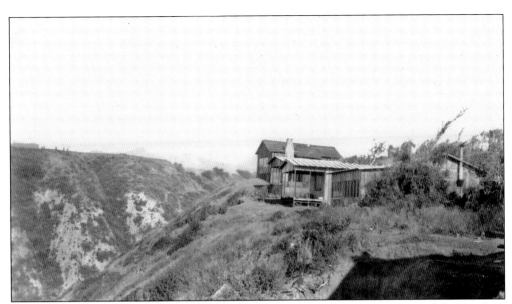

SHANTYTOWN. This shack enjoyed an unparalleled view of the Santa Monica Bay and the coastline. There were a number of these ad hoc vacation homes on the bluff that became the Huntington Palisades. The Pacific Palisades Association leadership visualized instead an upscale neighborhood with underground utilities, wide streets, distinctive lights, and landscaped parks.

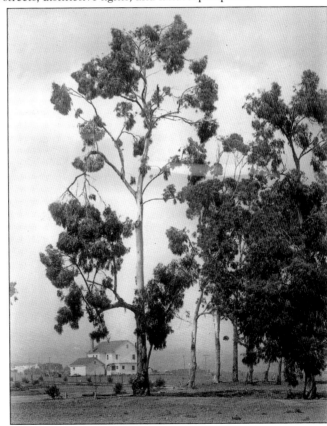

EARLY HUNTINGTON PALISADES. Thirty years later, Kinney's eucalyptus trees are large and form the early landscaping for the new Huntington Palisades. This photograph shows a substantial farmhouse that predates the development of the tract. Early development of the other parts of the Pacific Palisades is visible in the background.

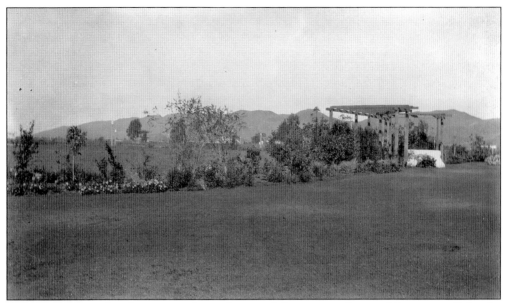

PARKS AND VIEWS. Land was set aside on the rim of the mesa in the new Huntington Palisades for a small park overlooking the ocean and coastline. The park is still a favorite spot for Palisades residents to enjoy the view. The lots on either side and across the street are now built up.

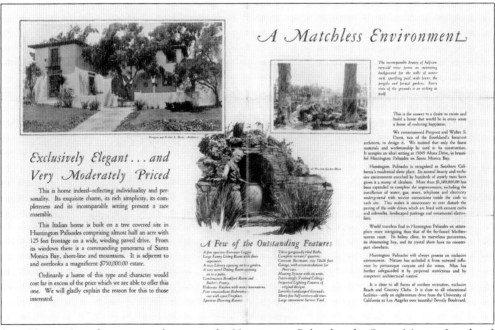

SPEC HOUSE. In order to attract buyers to the Huntington Palisades, the Santa Monica Land and Water Company often built spec houses as a sample of what the developers expected residents to build in the neighborhood. This Italian-style home was designed in the 1930s by Pierpont Davis and Walter S. Davis, two prominent California architects. It included many amenities such as a concrete basement, a laundry chute, and a three-car garage.

FOR SALE. Once the house was built, it was lavishly landscaped and advertised for sale. This particular home was featured in many advertisements for the Huntington Palisades as typical of the neighborhood. It included a coffered ceiling in the dining room, a butler's pantry, and three "gorgeously" tiled baths. The house was advertised as having ocean and mountain views, as well as "half-century old trees."

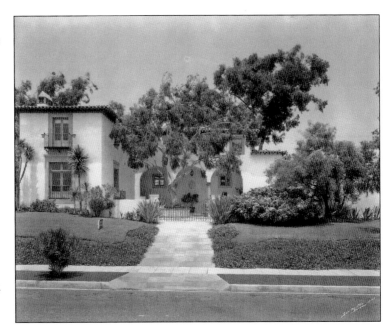

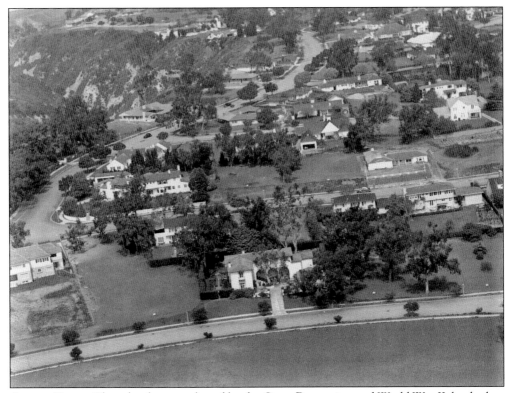

ALTATA DRIVE. Though sales were slowed by the Great Depression and World War II, by the late 1940s homes were beginning to fill the lots in the Huntington Palisades. This photograph shows the home built to advertise the tract in the late 1930s, as well as some of its rear neighbors. The curving road on the rim of the Potrero Canyon to the left is Alma Real Drive.

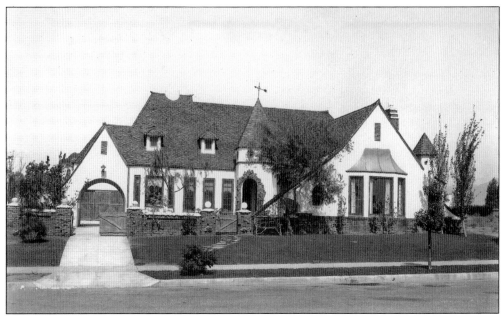

CUSTOM STYLES. Reflecting the taste of their owners, houses in the Huntington Palisades were built in many different styles. Since many were constructed in the 1950s, they were often built in the California ranch style popularized by Sullivan Canyon developer Cliff May. Others were built in the Spanish Colonial Revival style. The varying designs give the area much of its character and distinctiveness. The size and design of the houses being built were (and are) regulated by the covenants, conditions, and restrictions (CC&Rs) that each owner must agree to when purchasing a home. The CC&Rs cover such things as setbacks, a minimum size, and the cost of the house built, as well as race and ethnicity of the buyers. That last part of the CC&Rs was voided in the 1960s by the civil rights act, but the other restrictions are still in place and are enforced.

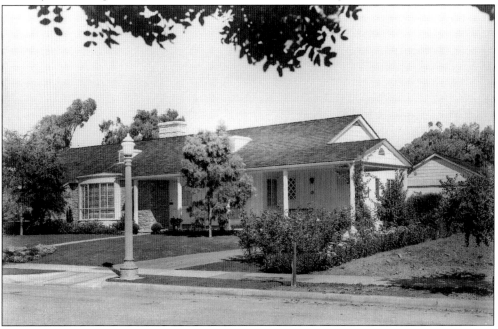

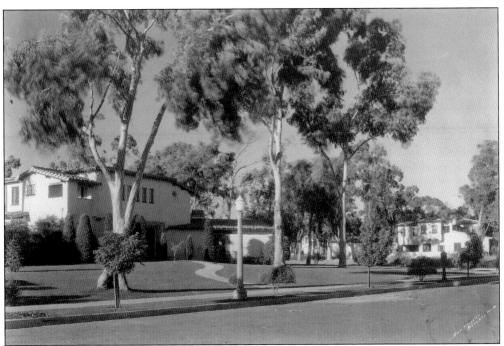

ON THE CORNER. This home was built on the corner of Almoloya and Toyopa Drives and is a good example of the Mediterranean style of homes constructed in the Huntington Palisades. Set well back from the street, it is built to take advantage of its spacious lot. The trees planted by the developer are still small, so this home was probably built sometime in the 1930s, making it an early home in the area.

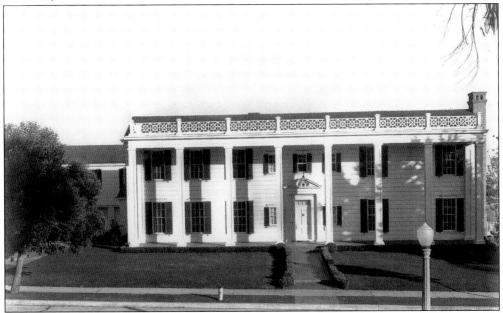

TARA WEST. This home's architecture owes more to the antebellum South than its California location. Its distinctive look adds to the ambiance of Chautauqua Boulevard. Local lore suggests it was built by a displaced Southern belle homesick for her roots.

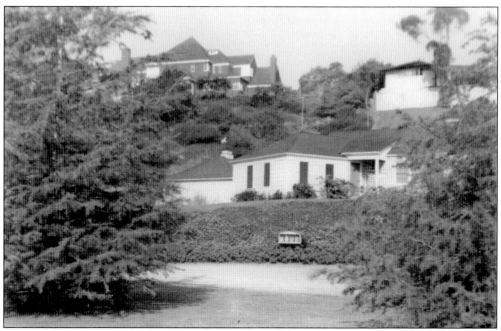

THE OUTER HUNTINGTON. The small mesa across Chautauqua Boulevard from the Huntington Palisades was developed separately and was never covered by the Huntington CC&Rs. Named for James Isaac Vance, a Presbyterian minister, the four homes on upper Vance Street were designed by John Byers prior to World War II but were not built until the war was over. This photograph looks up from Vance Street to the Huntington Palisades on the mesa above.

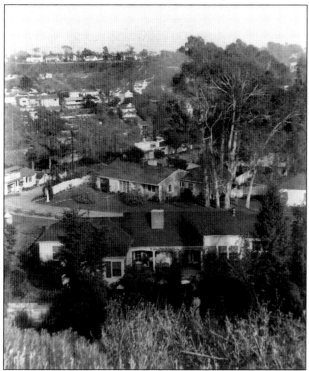

LOOKING BACK. This photograph was taken from the Huntington Palisades across Vance Street, looking across the Santa Monica Canyon toward Adelaide Drive. The two houses on the left were built before the Vance Street area was developed. One of these houses was eventually demolished after a landslide undercut its foundation. The homes in the foreground were designed by architect John Byers.

Six

THE RESIDENTS
FAMOUS AND PRIVATE

HORSES AND PONIES. The Palisades Tract in Santa Monica was developed when horses were still the primary method of transportation. Children learned to drive carts and ride at an early age. This small pony cart is being driven by Louise Hunt, daughter of Myron Hunt. Her passengers include Anita Thomas on the left, Dorothy Gillis peeking from behind Louise, and Nan Vail in the front.

THE MANDOLIN CLUB. A favorite outing for the children who lived in the Palisades Tract was to trek to the mesa Huntington Heights that became Vance Street for a meeting of the Mandolin Club. Also known as Theodore Best Juvenile Orchestra, the young people picnicked and played mandolins and guitars. Best had permission to use the mesa during the summer and often camped there. Best is to the far left in this photograph.

DOROTHY GILLIS. The youngest daughter of R. C. Gillis was born in Santa Monica and lived most of her life in Santa Monica and the Pacific Palisades. She often helped her father with his housing developments by planting trees and supervising the landscaping. Dorothy Street in Brentwood is named for her.

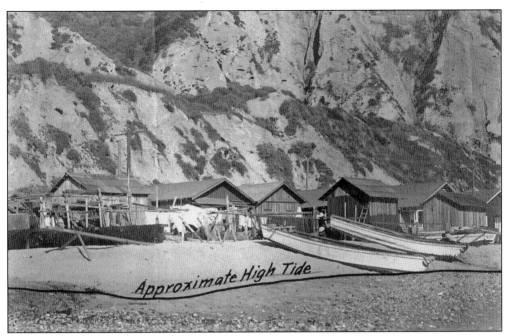

FRESH FISH. With the demise of the Long Wharf, a small village of Japanese fishermen built a shantytown at the foot of the bluffs on what was to be the Pacific Palisades beach. In this photograph, their laundry is drying on a line, and their boats are drawn up on the beach. Someone has marked the high-tide line on the photograph.

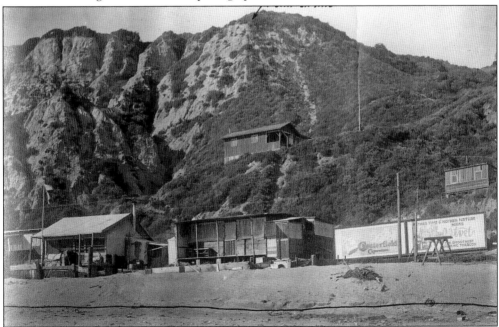

CHESTERFIELDS. The billboard in this photograph displays a Chesterfield advertisement. In the ad, cigarettes are touted as smooth and good for you. The Japanese village took root in 1899 when Hatsuji Sano leased land from the Southern Pacific and built some small dwellings. Eventually about 300 people lived and worked in the village tucked under the cliffs.

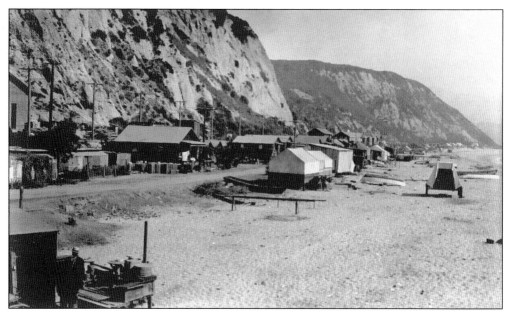

TOURIST RENDEZVOUS. During its heyday, the village hosted Japanese tourists who were seeking sea and sand. Two hotels thrived in the area. Japanese filmmakers also came to make movies using its picturesque scenery as a backdrop. The village was condemned in 1920 because of its open sewers. The buildings were torn down, and the village disappeared. The residents relocated to San Pedro and other California coastal cities.

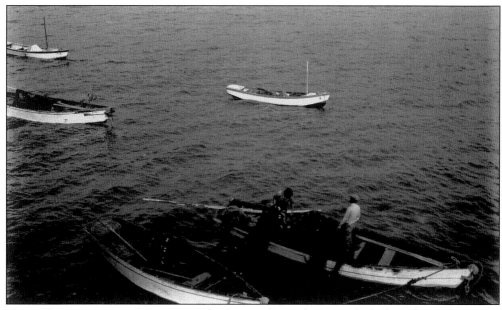

TUNA, YELLOWTAIL, AND MACKEREL. The 30 or so boats that were docked on the sand near the shacks made the most of the Santa Monica Bay's bounty, pulling in about 30 tons of fish per day. The fish were shipped daily into Los Angeles on a special morning train.

RUSTIC RESIDENTS. George and Katherine Edmund took up permanent residence in Rustic Canyon in 1895, purchasing land from Sen. John Jones and Arcadia Bandini de Baker. Katherine Edmund was a cousin of Frances Gillis, the wife of R. C. Gillis. The couple built a rustic home on the rim of the canyon and raised their daughter Betty there.

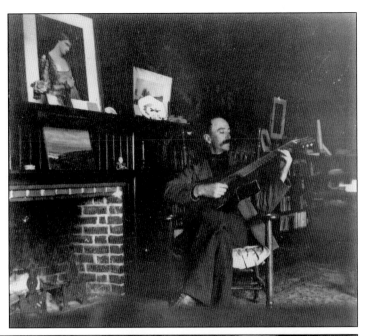

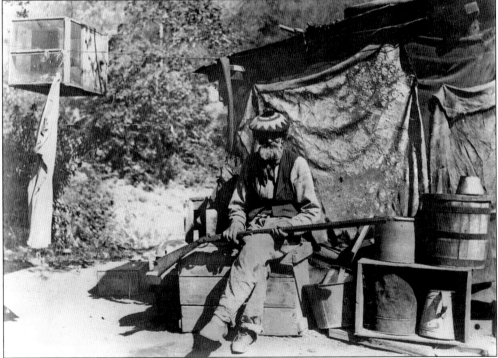

SAM CARSON. The nephew of the famous Native American scout Kit Carson, Sam Carson lived in Rustic Canyon during his later years. He was well known to the area residents and often sold firewood to Gillis, who used to pay him even though the firewood had probably been cut from his own land. In this photograph, Carson poses with a long rifle that previously belonged to his uncle Kit Carson. He is buried in the Marquez family cemetery. (Courtesy of the Santa Monica Public Library Image Archives.)

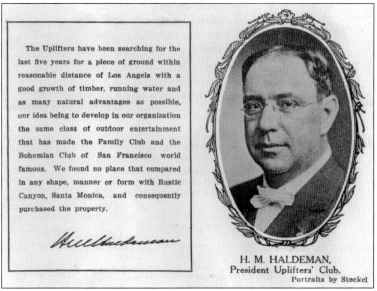

The Uplifters have been searching for the last five years for a piece of ground within reasonable distance of Los Angels with a good growth of timber, running water and as many natural advantages as possible, our idea being to develop in our organization the same class of outdoor entertainment that has made the Family Club and the Bohemian Club of San Francisco world famous. We found no place that compared in any shape, manner or form with Rustic Canyon, Santa Monica, and consequently purchased the property.

Hull Haldeman

H. M. HALDEMAN,
President Uplifters' Club.
Portraits by Steckel

UPLIFTERS. Harry Marston Haldeman was an active member of the Los Angeles Athletic Club, as well as the owner of the Pacific Pipe and Supply Company. He was a founding member of the Uplifters, a small group of athletic club members who banded together to "uplift art and promote good fellowship." In 1921, the group began creating a permanent home for its activities by purchasing 16.8 acres in Rustic Canyon, the Edmund property, from the Huntington Beach Methodist Assembly. The group included L. Frank Baum, author of the Oz books, studio head Hal Roach, Will Rogers, and many other notable Angelenos. As the photograph below shows, horseshoe tournaments were popular. Pictured are, from left to right, Herman Paine, Walt Graning, Arthur Holliday, Lee Ford, and Cecil Frankel. Leland Merritt Ford was a congressman and developed real estate in the Pacific Palisades, including the Bay Theatre property. (Courtesy of the *Herald-Examiner* Collection/Los Angeles Public Library.)

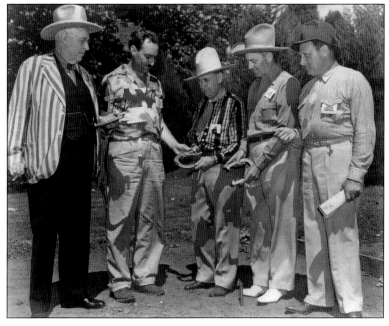

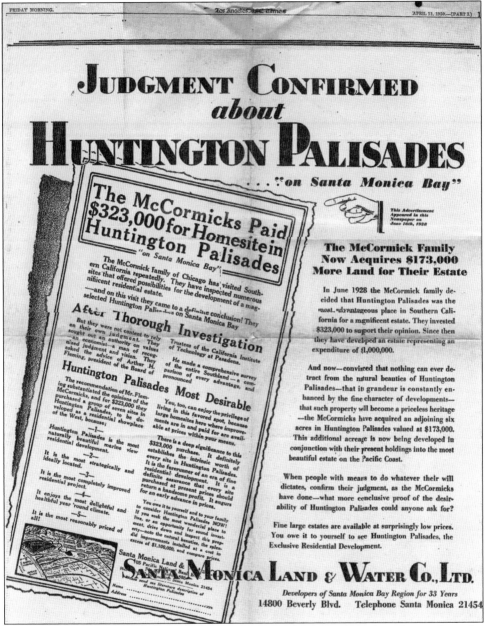

JUDGMENT CONFIRMED
about
HUNTINGTON PALISADES

... *"on Santa Monica Bay"*

This Advertisement Appeared in this Newspaper on June 16th, 1928

The McCormicks Paid $323,000 for Homesite in Huntington Palisades
"on Santa Monica Bay"

The McCormick family of Chicago has visited Southern California repeatedly. They have inspected numerous sites that offered possibilities for the development of a magnificent residential estate.

—and on this visit they came to a definite conclusion! They selected Huntington Palisades on Santa Monica Bay

After Thorough Investigation

But they were not content to rely on their own judgment. They sought out an authority on values—an economist—a man of recognized judgment and vision. They asked the advice of Arthur H. Fleming, president of the Board of Trustees of the California Institute of Technology at Pasadena.

He made a comprehensive survey of the entire Southland—a comparison of every advantage, and pronounced

Huntington Palisades Most Desirable

The recommendation of Mr. Fleming substantiated the opinions of the McCormicks, and for $323,000 they purchased a group of seven sites in Huntington Palisades, to be developed as a residential showplace of the West, because;

—1—
Huntington Palisades is the most naturally beautiful marine view residential development.

—2—
It is the most strategically and ideally located.

—3—
It is the most completely improved residential project.

—4—
It enjoys the most delightful and healthful year 'round climate.

—5—
It is the most reasonably priced of all!

You, too, can enjoy the privilege of living in this favored spot, because large homesites here where improvements are in and paid for are available at prices within your means.

There is a deep significance to this $323,000 purchase. It definitely establishes the intrinsic worth of every site in Huntington Palisades. It is the forerunner of an era of fine residential development. It is a definite assurance that every site purchased at present prices should return a handsome profit. It augurs for an early advance in prices.

You owe it to yourself and to your family to consider Huntington Palisades NOW! If you seek the most wonderful place to live, or an opportunity for sound investment, drive down and inspect this property—note the natural beauties, the splendid improvements installed at a cost in excess of $1,100,000, and compare prices.

Santa Monica Land &
708 Pacific Mutual Bank Building
Santa Monica 21454
Send me literature descriptive of
Huntington Palisades
Name
Address

The McCormick Family Now Acquires $173,000 More Land for Their Estate

In June 1928 the McCormick family decided that Huntington Palisades was the most advantageous place in Southern California for a magnificent estate. They invested $323,000 to support their opinion. Since then they have developed an estate representing an expenditure of $1,000,000.

And now—convinced that nothing can ever detract from the natural beauties of Huntington Palisades—that its grandeur is constantly enhanced by the fine character of developments—that such property will become a priceless heritage—the McCormicks have acquired an adjoining six acres in Huntington Palisades valued at $173,000. This additional acreage is now being developed in conjunction with their present holdings into the most beautiful estate on the Pacific Coast.

When people with means to do whatever their will dictates, confirm their judgment, as the McCormicks have done—what more conclusive proof of the desirability of Huntington Palisades could anyone ask for?

Fine large estates are available at surprisingly low prices. You owe it to yourself to see Huntington Palisades, the Exclusive Residential Development.

SANTA MONICA LAND & WATER CO., LTD.

Developers of Santa Monica Bay Region for 33 Years
14800 Beverly Blvd. Telephone Santa Monica 21454

HUNTINGTON HYPE. By 1928, the Huntington Palisades was actively seeking buyers for its lots. Arthur H. Fleming, a prominent Angelino with ties to the McCormick family (of McCormick reaper fame) through his wife, Clara Fowler Fleming, convinced the family to purchase a sizable property in the Huntington Palisades. Fleming had a home in the Palisades tract and often invested money in R. C. Gillis's projects. He was one of the founders of the Troop Institute, now the California Institute of Technology. The McCormick family paid $323,000 for seven lots located on the rim of the development overlooking the coast in order to build a residential estate. The family had an estate in Montecito that was damaged in the 1925 Santa Barbara earthquake and was looking for a property in a more stable area to build an estate for Mary Virginia McCormick. The family eventually added several more lots to their holdings in the Huntington.

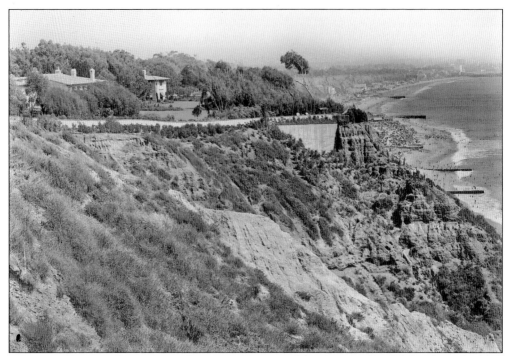

LANDSLIDE PROOF. The McCormicks were well aware of the danger of landslides along the bluff and built well back from the edge. They also dug tunnels under the property and installed drying equipment to reduce the danger of rainwater seepage weakening the foundations. One of these tunnels can still be seen at the foot of the bluffs along the Coast Highway.

McCORMICK ESTATE. The estate was built for Mary Virginia McCormick. Diagnosed as schizophrenic in early adulthood, McCormick was a recluse who was supervised throughout her life by a large staff of servants and nurses. She was fond of music, and three musicians were part of her permanent caregivers. After her death in 1941, the estate was used briefly as a retreat for wounded merchant marine sailors. After World War II, it was broken up and sold.

MARY VIRGINIA MCCORMICK. Born in 1861, Virginia McCormick grew up in Chicago as part of one of America's wealthiest families. The oldest daughter of Cyrus McCormick, the inventor of the McCormick reaper, she lived in a series of homes in Alabama and Tennessee built for her by her family because of her illness before moving to the Palisades. In addition to this estate in the Pacific Palisades, McCormick also maintained a home in Pasadena. (Courtesy of the Wisconsin Historical Society.)

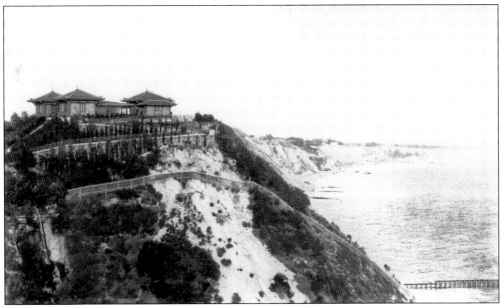

GARDEN ATTRACTION. Adolph Bernheimer and his brother Eugene were importers of Asian art treasures in the early 1900s. Adolph built this Japanese-inspired home and garden on the edge of the bluffs near the end of Sunset Boulevard and near Castellemmare after his brother's death in 1921. The brothers also built the Yamashiro mansion in Hollywood as a backdrop for their collections. It is now the Yamashiro restaurant.

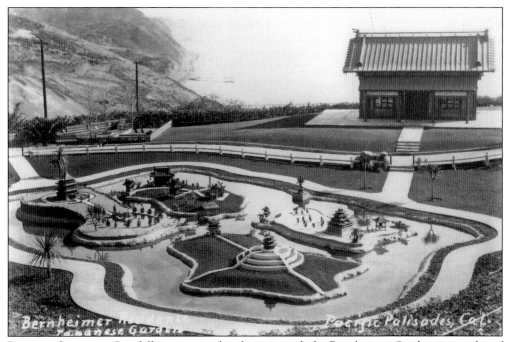

JAPANESE SERENITY. Carefully maintained and manicured, the Bernheimer Gardens were a bit of Japan laid out in the Pacific Palisades. Rare plants were brought from Tibet for the gardens. The residence was patterned on an ancient Chinese summer palace. The gardens were a popular tourist attraction until anti-Japanese sentiment reduced interest. A major landslide undercut the bluff below the property shortly after Adolph Bernheimer's death in 1944, dooming the property.

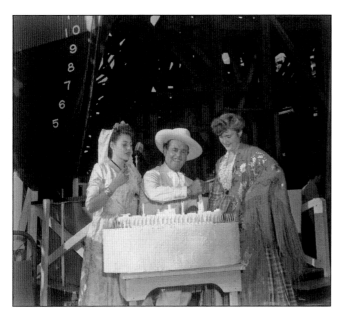

PANCHO. Leo Carrillo grew up in Santa Monica. Arcadia Bandini de Baker was his aunt, and his father was a prominent judge. Carrillo was a well-known vaudeville actor before moving on to the Broadway stage and a movie career. He is, however, perhaps best known for his television role as Pancho, the Cisco Kid's faithful sidekick. He lived in the Santa Monica Canyon for many years. In this 1942 photograph, he is christening the Liberty ship *Filipe de Neve*. (Courtesy of the Department of Special Collections, Charles E. Young Research Library, UCLA.)

HOMESPUN HUMOR. Will Rogers worked with Leo Carrillo in vaudeville. They appeared together at the Union Square Theater in New York. Rogers had a cowboy act and was known as the Cherokee Kid. Carrillo did ethnic impressions. They became lifelong friends, so Carrillo no doubt was one of the first people to interest Rogers in the area. Rogers bought a piece of land across Sunset Boulevard from the Uplifters Polo Field.

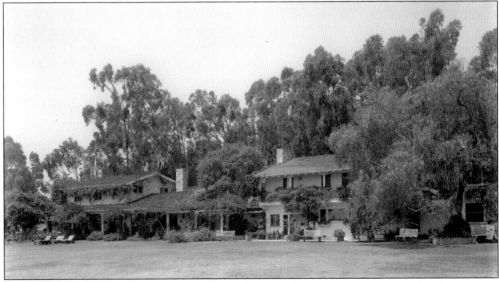

RAMBLING RANCH. Will Rogers built a sprawling ranch house on his Pacific Palisades property and created a polo field, which is still in use today. He also purchased beach property beneath the Pacific Palisades bluffs and developed plans for a resort. His death in an airplane crash in 1934 ended his plans, and eventually the land was sold to the state and became the Will Rogers State Beach Park.

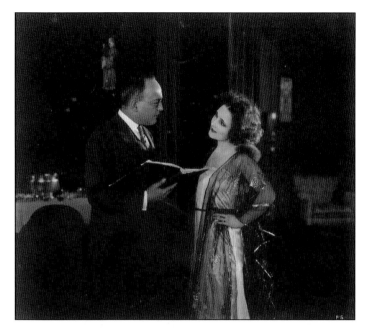

HUGO AND MABEL BALLIN. The Ballins' Huntington Palisades home on Almoloya Drive was completed in 1928, making them one of the earliest residents of the neighborhood. Hugo Ballin was a movie director and a gifted muralist. His wife was a well-known silent film star. Ballin directed more than 100 films, many starring his wife, including productions of *Jane Eyre* and *Vanity Fair*. (Courtesy of the Department of Special Collections, Charles E. Young Research Library, UCLA.)

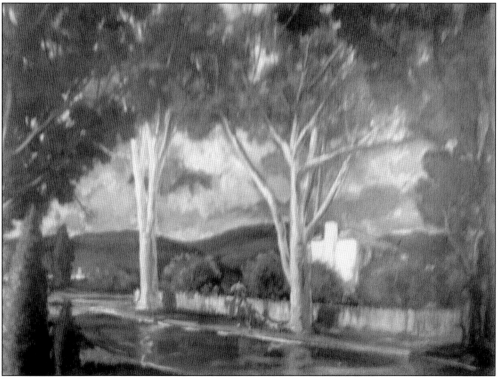

HUNTINGTON PALISADES AS ART. Hugo Ballin retired from the motion picture industry and devoted himself full time to painting. His home on Almoloya Drive included a two-story studio large enough to accommodate his mural works. His murals are on the walls of the B'nai B'rith Temple on Wilshire Boulevard, the Griffith Observatory, the Los Angeles Times Building, and many other Los Angeles sites. This painting is of his home on Almoloya Drive.

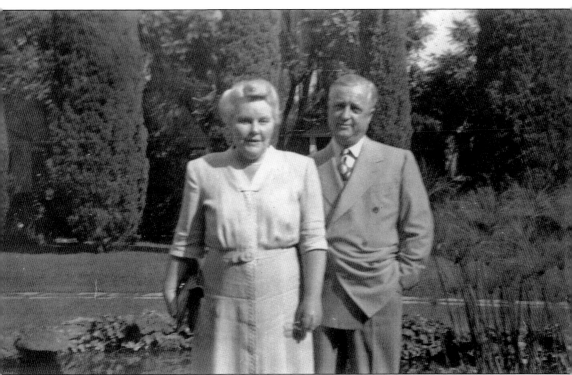

DOROTHY AND ARTHUR. In the 1930s, Dorothy Gillis and Arthur Loomis married, uniting two of the families instrumental in the early development of West Los Angeles. Arthur was born in Santa Monica and lived his childhood in one of the first homes built in the Westgate area of Brentwood. Dorothy was the daughter of R. C. Gillis and grew up spending her summers in the family home on Adelaide Drive. During World War II, they lived in Sullivan Canyon and then moved to the Huntington Palisades. Arthur was active in the Pacific Palisades real estate and politics. He was the first president of the chamber of commerce and led the fight to create a Pacific Palisades zip code.

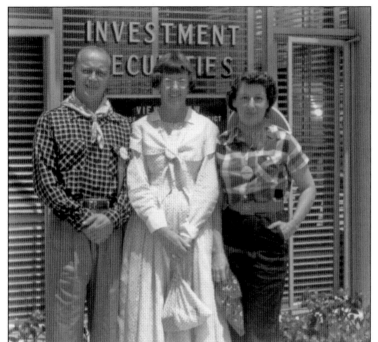

REAL ESTATE BROKERS. Pictured from left to right and costumed for the Fiesta Days celebration, Frank Petru, Kathleen Barienbrock, and Florence Simpson pose for the camera. Petru and Simpson were longtime real estate brokers in the Pacific Palisades. Barienbrock was the secretary for the Huntington Palisades Property Association for a number of years.

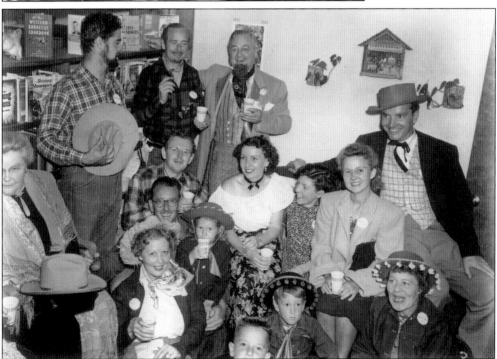

NEIGHBORS. In the 1950s, the Pacific Palisades was still a small town. Here residents gather in the new library dressed for the Fiesta Days celebration. The community had survived the Great Depression, but it was still a long commute on surface streets from the business centers of Los Angeles. That changed with the completion of the Santa Monica Freeway to the Coast Highway in 1965.

FRANK LEE. Dressed here for the Fiesta Days celebration, Frank Lee looks the part of the pioneer he was. During his long tenure with the Santa Monica Land and Water Company, he was instrumental in forming the Pacific Land Corporation, the successor to the Pacific Palisades Association. He directed the company's real estate sales.

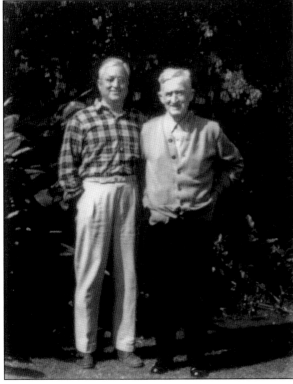

LOOMIS AND LOOMIS. Laurence Duncan Loomis and Arthur Loomis (left), father and son, pose for this photograph sometime in the 1950s. L. D. Loomis was one of the developers of the Westgate and several other tracts in Brentwood. He lived on San Vicente Boulevard for many years. Arthur followed in his footsteps, working as a real estate agent and stockbroker.

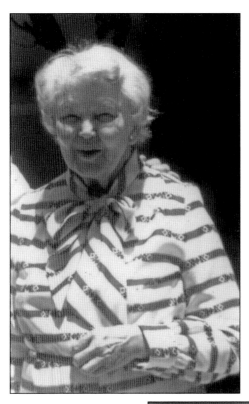

MISS FLAGG. Lois Flagg worked for the Santa Monica Land and Water Company all of her business career. A fixture in the Pacific Palisades, Miss Flagg, as she was always known, was a fountain of knowledge about the early days of the Pacific Palisades. This photograph was taken at her retirement party after 55 years with the company.

REAGAN FOR GOVERNOR. Ronald and Nancy Reagan lived in the Riviera section of the Pacific Palisades for a number of years before he was elected president. In this picture, fellow Palisadians Fred W. Marlowe (left) and Arthur Loomis (right) escort Reagan into a California Realty Estate Association (CREA) state convention in the early 1960s. The CREA was instrumental in convincing Reagan to run for governor and helped fund his campaign.

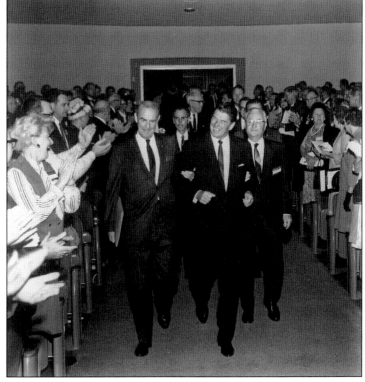

Seven

THE HAPPENINGS
MEMORABLE MOMENTS

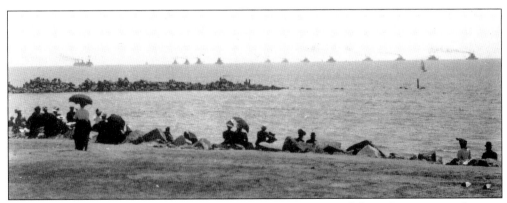

THE GREAT WHITE FLEET. In April 1908, Santa Monica welcomed the U.S. Navy on its historic trip from the Atlantic seacoast to Japan with celebrations and gala balls. The 16 battleships and four destroyers were quite a sight on the horizon as they headed for San Francisco. Residents lined the beaches to wave goodbye after the fleet's weeklong port call.

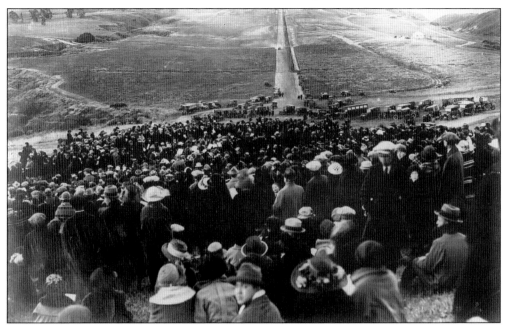

EASTER, 1922. The first Sunrise Service was held in 1922 on Peace Hill in the new Pacific Palisades development. The road in the picture is Via de la Paz, and the ocean is in the distance. Not much else exists at this point. There were around 5,000 people present though, so the organizers must have been excited about the interest in the new community. (Courtesy of the Zola Clearwater Collection.)

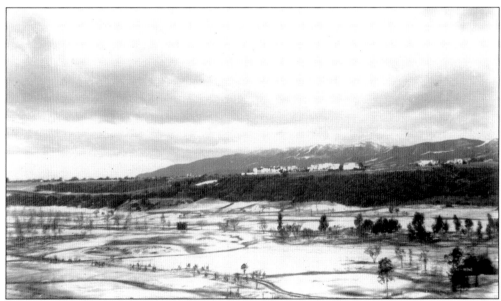

SNOWSTORM. It does not snow often in Southern California, so this photograph of the Riviera Golf Course covered in the white stuff is unusual. This freak snowstorm hit the area on January 15, 1932, and provided the locals with the ability to make snowmen and throw snowballs. The sun returned everything to normal the next day, but it was a memorable experience for the residents.

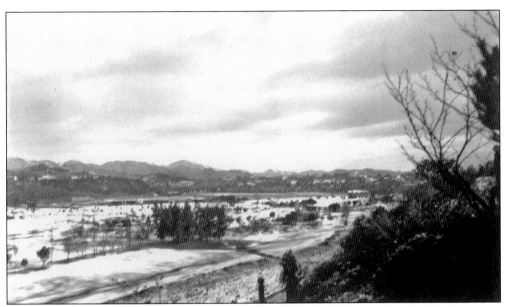

GOLF COURSE BLANKET. This photograph was taken from the backyard of one of the homes on La Mesa Drive and shows the amount of snow that fell that day. It was enough to cover the golf course with a thick blanket of white.

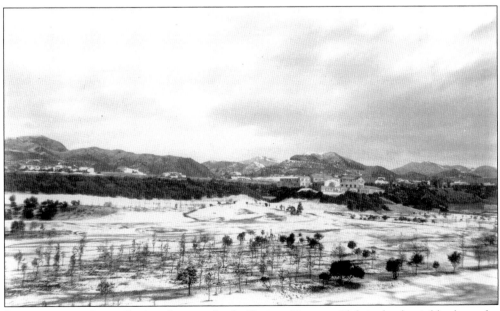

RIVIERA IN THE SNOW. In this photograph, the Riviera Country Club is clearly visible above the snow-blanketed golf course. School was let out for the day, and the children enjoyed sledding on the greens and making snow angels. The newspaper headline of the day summed it up, "Snowfall blankest South-Bay district—Weather has a joke on the Southland."

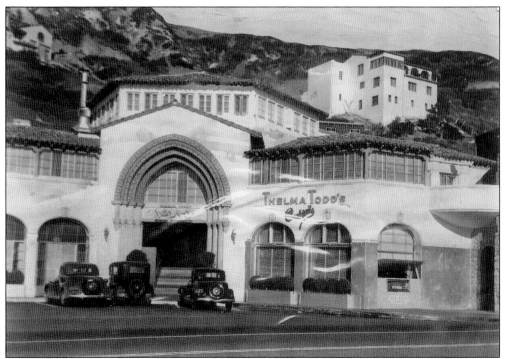

MURDER IN THE PALISADES. In the 1930s, Thelma Todd was the attractive blonde darling of Hollywood. She died under mysterious circumstances in the Pacific Palisades. Known for her hard partying, she opened a roadhouse called Thelma Todd's Sidewalk Café in the building pictured here. She was found dead in the garage on a Sunday morning. No satisfactory explanation was ever found for how she died. (Courtesy of the *Herald-Examiner* Collection/Los Angeles Public Library.)

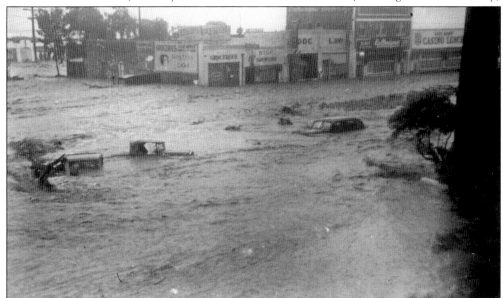

IT NEVER RAINS. In March 1938, Los Angeles received 4 inches of rain in less than 24 hours. While that might not be much for some parts of the country, it was a 100-year flood for Los Angeles. The water swamped the Santa Monica Canyon and everything in it.

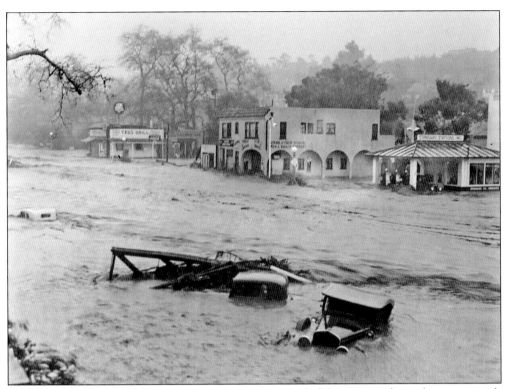

WATER AND DEBRIS. Just about anything that was not nailed down came down the canyon with the floodwaters. From the look of this picture, the water must have been 4 to 5 feet deep. Note Ted's Grill, a longtime Santa Monica Canyon fixture, at the center left of the photograph.

THEN THERE WAS MUD. The water brought torrents of mud and rock down the canyons and buried cars and buildings. The cleanup required weeks of digging out. The Red Cross reported that 6,000 Angelinos were left homeless. Many canyon residents were evacuated, including Leo Carrillo.

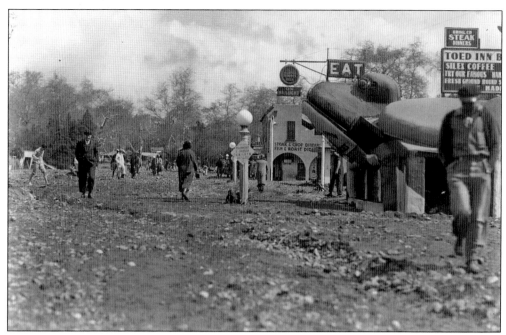

INSPECTING THE DAMAGE. Residents inspect the damage done to the canyon's businesses and infrastructure by water, rock, and mud. The City of Santa Monica was cut off from the rest of Los Angeles for days by flooded roads and washed-out bridges. Note the frog built into the "Toed" Inn entrance.

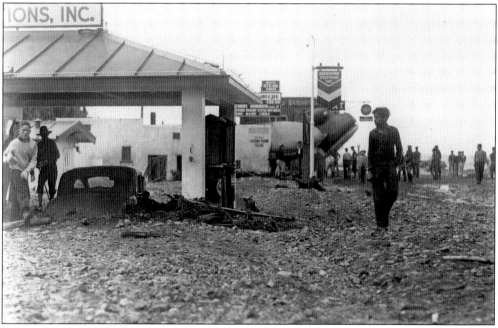

FILLING STATION. This driver must have rued the day he stopped for gas and found himself buried in a sea of rock and mud. Obviously flood control was needed to prevent this type of damage from happening again. One of the first improvements made after the cleanup was the concrete flood channel down the canyon.

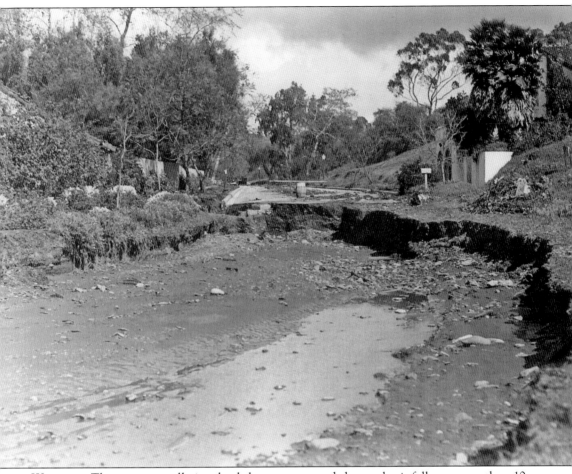

WASHOUT. The storm actually involved three storms, and the total rainfall was more than 10 inches in five days. One hundred fifteen people died, and more than 5,000 houses were destroyed. It would take many months to get everything back to normal. Bridges in the San Fernando Valley were out for years, requiring lengthy detours. College students were pressed into service to wade into basements and turn off furnaces. The Westwood Ho Golf Course in Sawtelle was a 4-mile lake. The lifeguard station was washed away. One lucky man was swept out of his home in his bathtub and deposited alive several miles down the canyon. A lone barrel and a piece of wood warn drivers that this Santa Monica Canyon street has been washed away by the flood. While the canyon was devastated, it quickly recovered and was cleaned up and rebuilt.

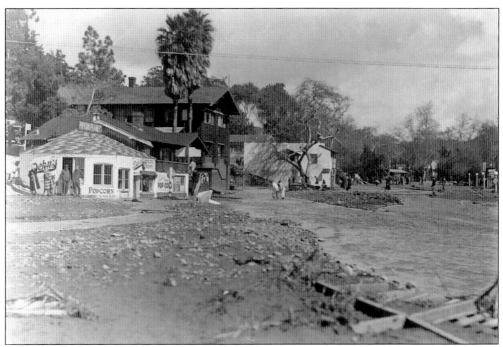

HIGH GROUND. The car to the left is parked on Chautauqua Boulevard safely out of the mess. This image shows that the other side of the canyon did not fare any better. Businesses and schools were closed all over Los Angeles while everyone dug out.

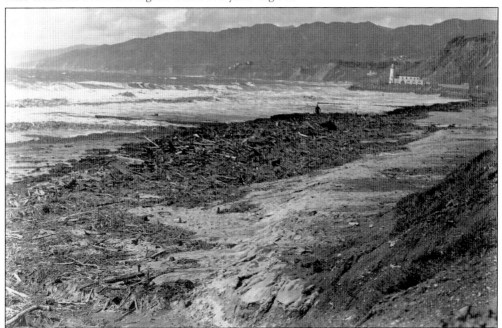

THE BEACH. Ultimately much of the water and debris made its way down to the beach, cutting new channels to the ocean. It would be awhile before beachgoers could bask on the sand. Fortunately the new flood control system worked well, and the canyon did not flood out again until 1980 when a car fell into the channel and blocked it during another drenching storm.

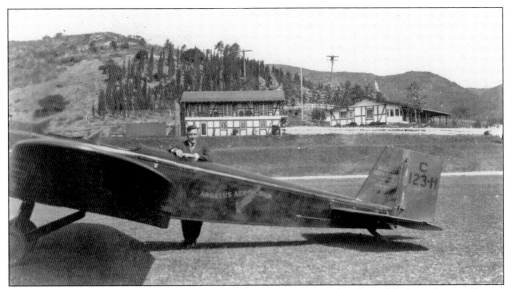

LANDING FIELDS. Will Roger's polo field was a large open space clearly visible from the air. Rogers sometimes used it as a landing field, as did other pilots when they needed a landing spot. This photograph shows Lindsey Gillis with his plane, an Aeromarine-Klemm, after a forced landing on the polo field. In 1930, a small airplane struck the mountain near Roger's ranch, killing three people.

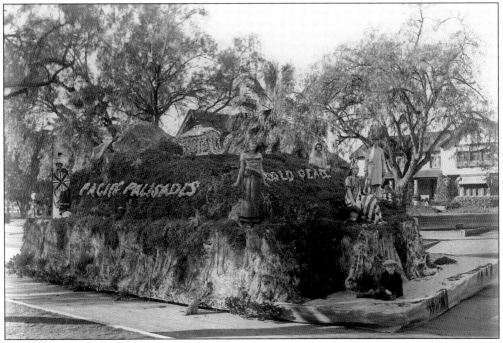

WORLD PEACE AND FLOWERS. By 1924, the Rose Parade was an established venue for advertising Los Angeles's mild winter climate. Movietone newsreels spread the images of a winter landscape devoid of snow and ice. Developing suburbs entered floats and vied for the grand sweepstakes prize. The Pacific Palisades Association float highlighted the theme of world peace. It also reproduced in flowers the signature bluffs that gave the community its name.

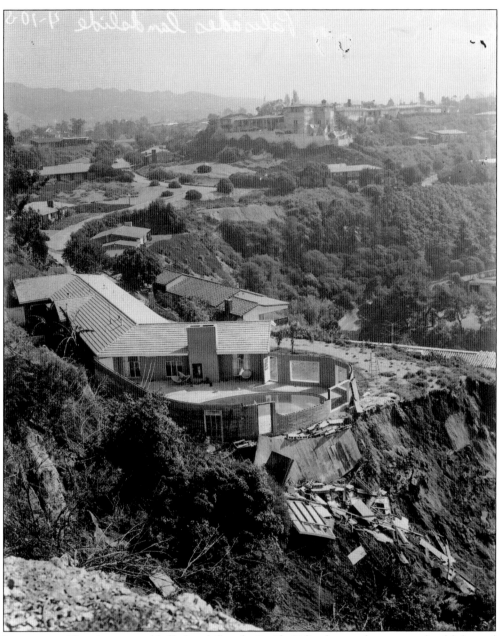

LANDSLIDES. The picturesque bluffs that define the Pacific Palisades are also prone to landslides and rockfalls. As the Coast Highway was widened to accommodate more traffic, the bluffs were often undercut. Rainwater and irrigation contribute to the problem. In March 1958, a major landslide closed the southern end of Via de la Paz, blocking it forever as an access road to the beach. Some 250 feet of the Coast Highway were covered to a depth of 30 feet. Two cars were caught in the landslide and carried out to sea. A second slide in April re-blocked the highway and killed a highway engineer clearing the first slide. The Castellammare area has also had numerous slides, losing parts of streets and houses. A 1967 slide caused the near collapse of the three-story Ocean Woods Terrace building in that area. This photograph shows the top of the 1958 slide. (Courtesy of the University of Southern California, on behalf of the USC Special Collections.)

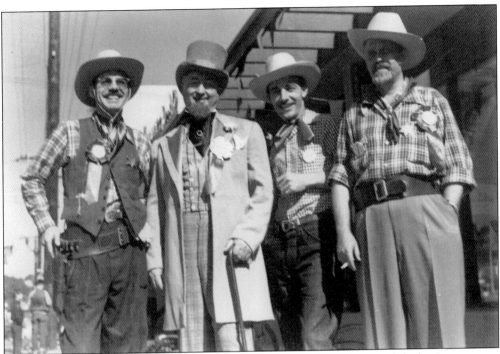

FIESTA DAYS. The war was over, the Pacific Palisades was growing again, and the business owners wanted to promote their town and their businesses. The Lions Cub hit upon the idea of holding Fiesta Days to celebrate their Western heritage and draw attention to the Pacific Palisades business district. Here costumed business owners, including Arthur Loomis (second from the left) and Rae Colvey (second from the right), pose on Antioch Street.

TURKEY GIVEAWAY. In the 1940s, a thriving turkey farm occupied part of Las Pulgas Canyon, so the Pacific Palisades Chamber of Commerce sponsored a turkey giveaway for Thanksgiving. Arthur Loomis (left) was the first chamber president, J. U. Chaffin (the manager of the Bay Theater) was vice president, and Phyllis Genovese (owner of the Letter Shop) was treasurer. Rae Colvey chaired the retail sales committee.

VINTAGE CARS AND LIONS. In addition to the parade, the 1949 Fiesta Days included a horse show, a rodeo, and a donkey ball game. Sixteen-year-old Mary Helen Peterson was chosen as the Fiesta Days queen and was crowned after her graduation from University High School. Los Angeles sheriff Eugene Warren Biscailuz was the guest of honor.

THE BAND MARCHED ON. This marching band is one of many that played for the crowds during this Fiesta Days parade. Note the announcer in the background wearing his Western shirt and cowboy hat. The Business Block is in the background.

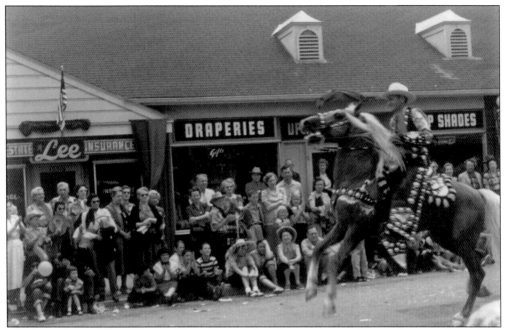

PARADING THROUGH TOWN. The Fiesta Days included a parade with horses, floats, and marching bands. This photograph shows one of the early parades and the shops that lined Antioch Street in the early 1950s. Lee Insurance (left) was founded in 1913, making it one of the earliest businesses in the area.

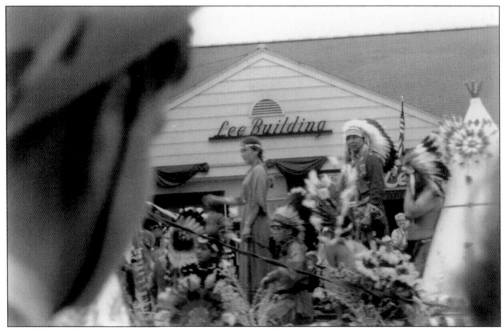

THE WILD WEST. This group of Native Americans dressed in native garb must have thrilled the crowd with their feathered headdresses and tepee. The first parade was held in mid-June 1949. The parade is the only survivor of the Fiesta Days celebration. It lives on as the annual Fourth of July parade, which is now put on by the Palisades Americanism Parade Association.

CITIZEN OF THE YEAR. Every year someone is designated the Citizen of the Year by the *Palisadian Post* in recognition of his or her contributions to the community. Arthur Loomis was Citizen of the Year in 1956. In this photograph, taken at the 1973 Fourth of July parade, he rides in a vintage Thunderbird with his great-grandsons—marking five generations of involvement with Santa Monica, Brentwood, and the Pacific Palisades. The Pacific Palisades Community Council also awards the Golden Sparkplug award to those who have initiated some benefit to the community. There is an honorary mayor selected each year—usually someone from the entertainment industry who lives in the community. Honorees have included Mel Blanc, the voice of Bugs Bunny, as well as Chevy Chase, Dom DeLuise, Nanette Fabray, Walter Matthau, and Vivian Vance of *I Love Lucy* fame.

Nine

THE INSTITUTIONS
SERVING THE COMMUNITY

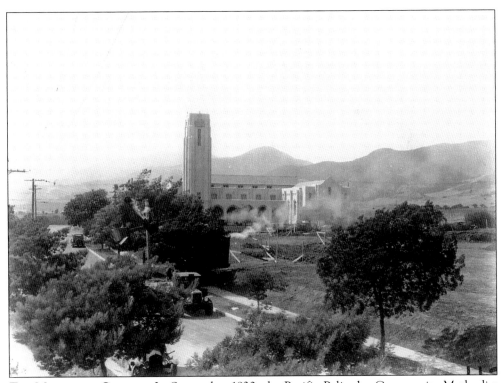

THE METHODIST CHURCH. In September 1930, the Pacific Palisades Community Methodist Episcopal Church was less than a year old. It was dedicated in February 1930. The church was designed to seat 350 people in its social hall. Land for the church was donated by the Pacific Palisades Association. The dust cloud from the construction site in this photograph signals the beginning of Palisades Elementary School.

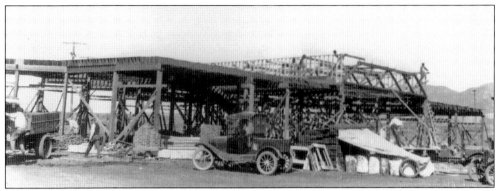

THE BUSINESS BLOCK. The Pacific Palisades Association set aside land and money to build a small business center for its new community. The Business Block was set on a wedge of property near the center of the mesa. It was intended as the center of a civic center that would include a hotel and a library. Built of unreinforced brick and stucco, it remains the center of the community today. (Courtesy of the Zola Clearwater Collection.)

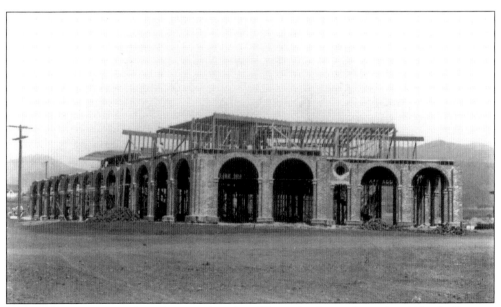

CONSTRUCTION ZONE. Built in the Spanish Colonial Revival style popular in the 1920s, the Business Block included a second story on each end for offices and a ground floor of shops behind an arcade of arches and columns. Its unreinforced brick construction proved to be a problem when Los Angeles passed strict building codes in the 1980s. (Courtesy of the Zola Clearwater Collection.)

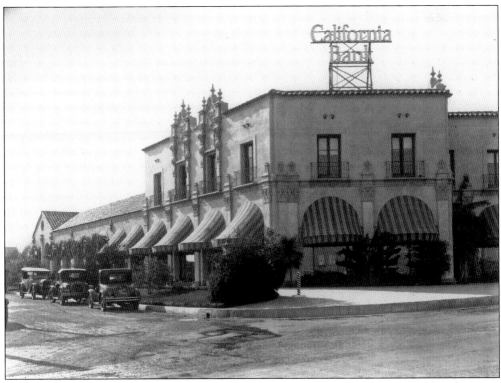

AWNINGS AND CROCKETING. When completed, the Business Block was decorated with ornate columns and roof finials. The City of Los Angeles ordered the roof decorations removed after the 1933 Long Beach earthquake. A remodel done during the 1950s replaced the canvas awnings on Antioch Street with a metal shade. The awnings returned in the 1980s. (Courtesy of the Santa Monica Land and Water Company Archives.)

UCLA STUDENT COUNCIL. This view of the Business Block shows the Via de la Paz side of the building. For many years this part of the structure was the office of the Santa Monica Land and Water Company before becoming a bank. The UCLA Student Council visited the area and posed for this picture in 1928.

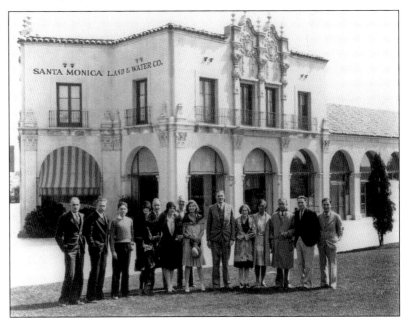

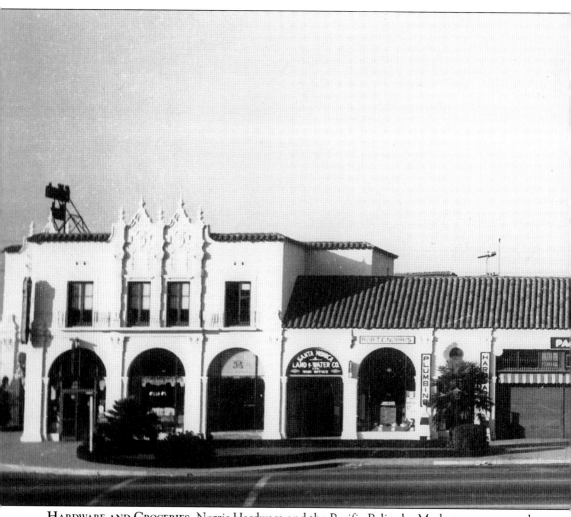

HARDWARE AND GROCERIES. Norris Hardware and the Pacific Palisades Market were among the first tenants in the new Business Block, along with the Santa Monica Land and Water Company. The center section of the building served as a grocery well into the 1970s. Norris Hardware is still owned by the Norris family and has been in business in the Pacific Palisades since 1925. The

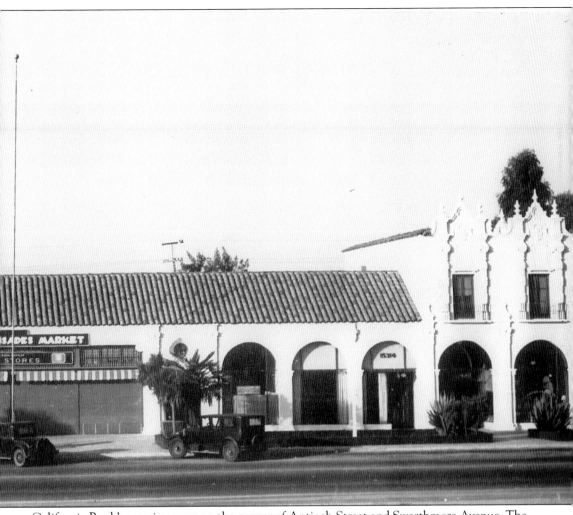

California Bank's premises were on the corner of Antioch Street and Swarthmore Avenue. The flagpole is one of the tallest in the area and requires the services of the local hook-and-ladder fire truck when it needs repairs.

CIVIC PROMOTION. This brochure followed a fairly typical promotional format. There is a map of the Pacific Palisades and a number of advertisements for local businesses. The picture of the Business Block clearly shows the location of the California Bank on the corner of Antioch Street and the park across the street.

Map of

PACIFIC PALISADES

on Santa Monica Bay

Including **PACIFIC PALISADES, HUNTINGTON PALISADES, RIVIERA, MANDEVILLE CANYON, MIRAMAR ESTATES, CASTELLEMMARE, AND SANTA MONICA CANYON.**

The Business Center on Sunset Boulevard

GROCERIES. The Pacific Palisades Grocery was a successor to the Pacific Palisades Market. Note the five-number telephone number–this was before the Gladstone prefix came into use. While this brochure is not dated, it was probably done sometime in the late 1930s or early 1940s.

NORRIS HARDWARE.
Few businesses can
boast of being in
one community for
over 75 years under
the same family
ownership. Norris
Hardware is one
of the few. Started
in 1925 by Robert
Norris, it has been
a fixture in the
Pacific Palisades
ever since. Its first
location was in the
Business Block,
and it relocated
to Swarthmore
Avenue north of
Sunset Boulevard
and now is located
in the old Bay
Theater building.

AUTOMOBILE CARE. Pacific Palisades residents needed their automobiles, and Sauers Service made sure they were serviced. Florian "Jack" Sauer opened his service station after Beverly Boulevard (now Sunset Boulevard) was completed through the Pacific Palisades to the ocean. The station was known to local aviators for the arrow Sauer painted on his roof as a navigational aid.

ROBERT CONRAN GILLIS. R. C. Gillis bought the Santa Monica Land and Water Company in 1904 and owned it until his death in 1947. During that 42-year period, the company was involved in the transformation of West Los Angeles from rolling open fields and hills to streets, homes, businesses, and schools for some 80,000 people. When the Great Depression hit and the Pacific Palisades Association could no longer meet its obligations, Gillis took over most of its assets and liabilities and transferred them into the Pacific Land Corporation. This maneuver made sure that the Pacific Palisades would continue to develop into the originally envisioned community. The Santa Monica Land and Water Company continued to operate as a real estate company until the mid-1980s.

FROM THE BUSINESS BLOCK, 1929.
The view from the Business Block in 1929 shows open land and the houses rising on the Alphabet Streets. The man in profile is Louis Evans, a longtime employee of the Santa Monica Land and Water Company.

FROM THE BUSINESS BLOCK, 1971. The same window shows a very different view. Swarthmore Avenue has been put through and developed into a business area, Sunset Boulevard is a busy street, and the hills are covered in homes. The man in the window 42 years later is Frank Petru, a longtime real estate agent in the Pacific Palisades.

CORPUS CHRISTI CHURCH. As the Pacific Palisades grew, more services were needed. The Catholic Church split the area off from St. Monica's parish in Santa Monica in 1950 and purchased land in the Huntington Palisades for a new church. Fr. Richard Cotter was made the first pastor and given the job of building the new church and school. The school opened in 1951, and Mass was held in the Parish Hall until the completion of the new church in 1964. The church was designed in a modern style of red brick and oak accents. This picture was taken in February 1965 shortly after it opened. The convent and rectory were located across the street.

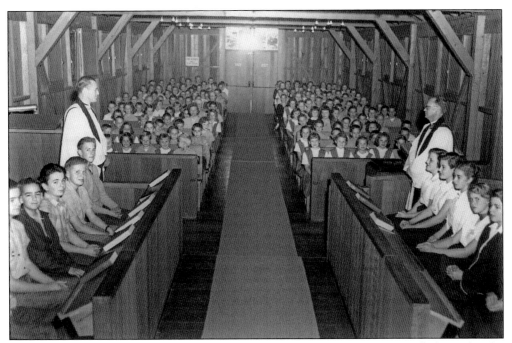

St. Matthews Episcopal Church. Founded in 1941, St. Matthews was originally located at the corner of Swarthmore Avenue and La Cruz Drive. Rev. Kenneth W. Cary was the first rector and relocated the church to its present site in Las Pulgas Canyon. This photograph is of the interior of the original church, which burned down in October 1978 during a brush fire. The new church was designed by Charles Moore and was dedicated in 1983.

School Days. St. Matthews opened its preschool in 1949 and the Parish Day School in 1950, both at the original Swarthmore Avenue location. This photograph shows the fifth-grade class of 1956 with their teacher, a Mrs. McDonald. St. Matthews has a campus of about 42 acres. There are 13 buildings and four residences on the property.

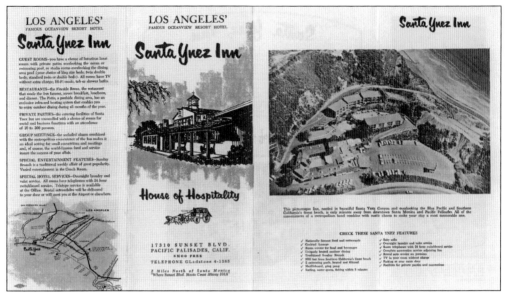

SANTA INEZ INN. Built in 1947, for many years the inn was the only place to dine out or put up visiting relatives for Palisadians. Located in Santa Inez Canyon, on the site of the Inceville Studios, the inn offered lanai rooms with views of the mountains and the coastline and 19 rooms around a patio and pool.

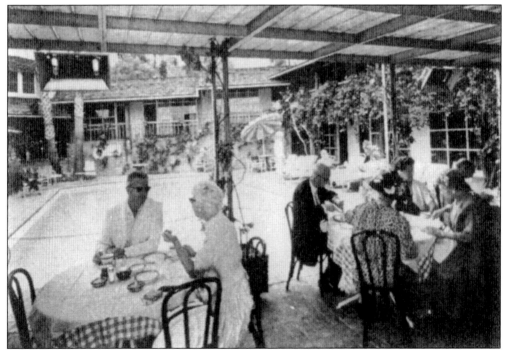

PATIO UNITS. Billed as a country inn by its architect, the swimming pool was surrounded by tables for outdoor dining. The brochure advertised that the temperature could be controlled with infrared heating, making it a year-round venue. The Santa Inez Inn's Terrance Room banqueting facility played host to numerous civic meetings, weddings, and parties.

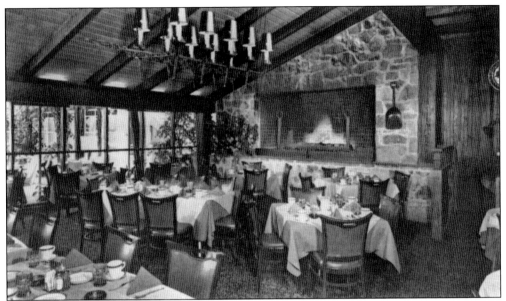

THE FIRESIDE ROOM. Known as the "hang-out of the stars," the Fireside Room was well known for its champagne brunches and rustic setting. In 1976, the Santa Inez Inn was sold to the Transcendental Meditation program and ceased to serve the community as a public venue.

MOVIE STAR RETREAT. The Santa Inez Inn was often used by movie stars as a tranquil retreat away from the Hollywood madness. Regular guests included Cary Grant, Joan Crawford, Howard Hughes, and many more. The property changed hands again recently and is now the site of the Waldorf School.

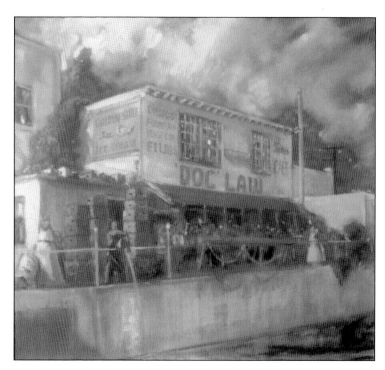

Doc Laws. The mouth of the Santa Monica Canyon has always been a cosmopolitan place with a slightly shady reputation. Doc Law was a sometime actor and a full-time character. He ran a pharmacy in the front part of his store and a speakeasy on the other side. This painting by Hugo Ballin shows the more interesting backside in full swing. The site is now a club called the Hideout. (Courtesy of the Loomis Family Collection.)

Roman Villa. J. Paul Getty built the Getty Villa as a copy of the Villa dei Papiri, which was destroyed by the eruption of Vesuvius in 79 AD, to display his collection of Greek and Roman art. While the entrance is in Malibu, the museum is actually located in the Pacific Palisades.

PARKING ISSUES. The Getty Villa opened in 1974, causing consternation among its neighbors because of parking issues. A compromise was worked out that required museumgoers to make parking reservations. Visitors were limited to the number of parking spaces that could be used each day. The reflecting pond is a favorite feature of the museum.

PAINTED WALLS. Each side of the peristyle that surrounds the reflecting pool is painted with murals. The museum was closed for renovation when the new Getty Center opened in Brentwood. It was totally renovated and reopened in 2006. It now houses only the antiquities collection and is a center for the study of the arts and cultures of ancient Greece, Rome, and Etruria.

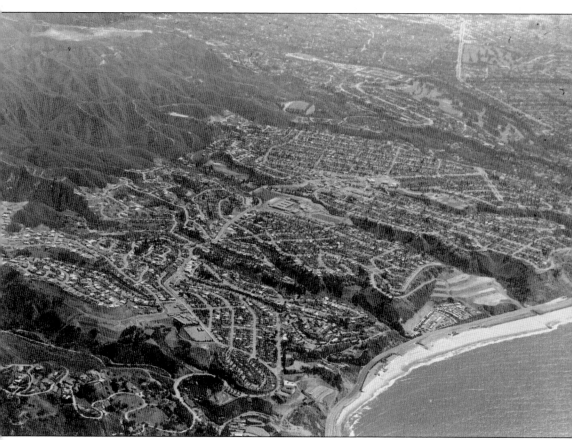

FROM MESA TO COMMUNITY. By the early 1960s, the Pacific Palisades had fulfilled its potential and grown into a full-fledged community spread out on the mesas about the bluffs that border the Pacific Ocean. The new high school is visible in the middle of the picture at the top of Temescal Canyon.

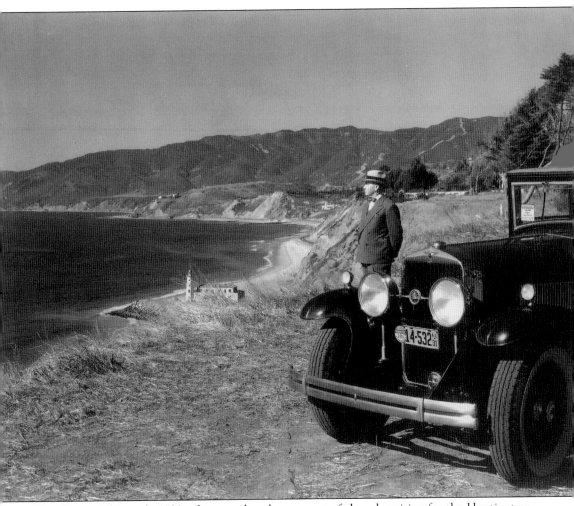

THE VIEWS. This early 1930s photograph, taken as part of the advertising for the Huntington Palisades, shows the view from the edge of the Huntington Palisades bluff looking north towards Malibu. The top of the lighthouse can be seen to the center left, and the Bel Air Bay Club is in the distance just to the left of Louis Evans. Evans sold lots for the Santa Monica Land and Water Company for many years. Note the Huntington Palisades brochure in his pocket.

BIBLIOGRAPHY

Carrillo, Leo. *The California I Love*. Englewood Cliffs, NJ: Prentice-Hall, Inc., 1962.

Drinkwater, Judy and Jan Loomis. *A Datebook for the Westsiders of Los Angeles: 1982*. Los Angeles: Santa Monica Bay Printing and Publishing Company, 1981.

———. *Yesterday Tripping–1984*. Los Angeles: Santa Monica Bay Printing and Publishing Company, 1983.

Ingersoll, Luther A. *History Santa Monica Bay Cities*. Los Angeles: Luther A. Ingersoll, 1908.

Loomis, Jan. *Brentwood*. San Francisco: Arcadia Publishing, 2008.

Loomis, Robert G. *Huntington Palisades*. Paper submitted to satisfy the requirement for BA-182, UCLA, 1956.

McGroarty, John Steven. *Los Angeles: From the Mountains to the Sea*, Vol. I–IV. Chicago and New York: The American Historical Society, 1921.

Minutes, Pacific Land Corporation, three unpublished volumes, 1913–1947. Santa Monica Land and Water Company Archive.

White, Carl F. *Santa Monica Community Book*. Santa Monica, CA: A. H. Cawston, 1953.

Young, Betty Lou. *Pacific Palisades: Where the Mountains Meet the Sea*. Pacific Palisades, CA: Historical Society Press, 1983.

———. *Rustic Canyon and the Story of the Uplifters*. Santa Monica, CA: Casa Vieja Press, 1975.

Young, Randy and Betty Lou Young. *Street Names of Pacific Palisades and Other Tales*. Pacific Palisades, CA: Pacific Palisades Historical Society Press, 1990.

INDEX

DISCOVER THOUSANDS OF LOCAL HISTORY BOOKS FEATURING MILLIONS OF VINTAGE IMAGES

Arcadia Publishing, the leading local history publisher in the United States, is committed to making history accessible and meaningful through publishing books that celebrate and preserve the heritage of America's people and places.

Find more books like this at
www.arcadiapublishing.com

Search for your hometown history, your old stomping grounds, and even your favorite sports team.